Artistic Secrets to Painting Tonal Values

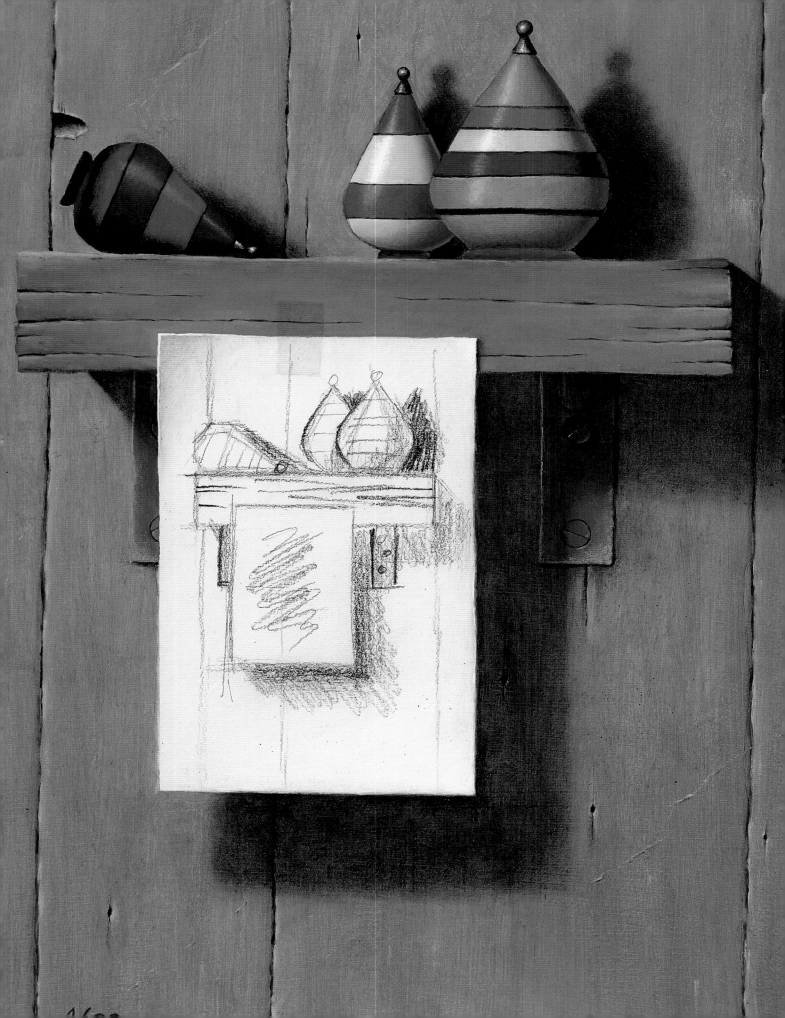

ARTISTIC *secrets*
TO PAINTING
tonal values

Alex Kedzierski

NORTH LIGHT BOOKS
Cincinnati, Ohio
www.nlbooks.com

Thanks to each artist for their permission to use their art. All works of art reproduced in this book have been previously copyrighted by the individual artists and cannot be copied or reproduced in any form without their permission. The artists are: Dorothy L. Angeli, John C. Bierley, David M. Hopkins, L. Maile Marshall and Ed Steinhilper.

Cover art: *Top Shelf*, Alex Kedzierski, 15"x 11" (38cm x 28cm) Oil and graphite on acrylic-gessoed watercolor paper Collection of the artist (photo by Donald J. Nargi)

Other fine North Light Books are available from your local bookstore, art supply store or direct from the publisher.

04 03 02 01 00 5 4 3 2 1

Library of Congress Cataloging in Publication Data

Kedzierski, Alex.
 Artistic secrets to painting tonal values./Alex Kedzierski.
 — 1st ed.
 p. cm.
 Includes index.
 ISBN 0-89134-925-1
 1. Painting —Techniques. 2. Colors. I. Title.
ND1500.K43 1999
751.4--dc21 99-27069
 CIP

Edited by Michael Berger
Production edited by Amy J. Wolgemuth
Interior designed by Angela Lennert Wilcox
Production coordinated by Erin Boggs
Cover designed by Stephanie Strang

To:
Donald James Nargi
For so very much!

ABOUT THE AUTHOR

Alex Kedzierski considers himself self-taught, although he did study briefly at the Art Students League of New York. He feels that "all artists are self-taught, no matter how much formal training they may have had, because they've really learned to paint by doing, not by listening, watching or reading. Of course," he admits, "studying with a painter who's already made all of the mistakes and has gone through the trial and error part of training helps to reduce the student's learning time!"

Alex is the founder and director of the Lycoming Art Students League in Montoursville, Pennsylvania, where he also teaches classes in oil and pastel painting. He is also a member of the Oil Painters of America. Alex's work can be found in private and corporate collections across the United States and in Japan.

ACKNOWLEDGMENTS

First, my deepest thanks to Mary Magnus, a former editor at *The Artist's Magazine*, who first contacted me about getting my work before the public in an illustrated article on color mixing. I am equally indebted to Greg Schaber, who took over the job of editing that article when Ms. Magnus left the magazine, and who strongly urged me to contact North Light Books with a proposal for a full-length book.

Many thanks to Greg Albert, who reviewed that first proposal and apparently found it worth considering. I also owe an incalculable dept of gratitude to Rachel Rubin Wolf. With incredible tact and grace, she wisely talked me out of my original idea (a general, run-of-the-mill book on oil painting) and talked me into writing what you find here. She then fought long and hard to get the new proposal approved. I only hope that she finds the end result worthy of her efforts!

Special thanks are due to Pamela Wissman, who began the job of editing the manuscript, and especially to Mike Berger, who took over the monumental task of making sense of a budding author's confused verbal meanderings. I am in awe, Mike! Associate editor Amy Wolgemuth then added her expertise in keeping the ball rolling and, even better, gave the first indication of when I would finally see the finished book. A thousand thanks to you, Amy.

Of course, there are dozens of other people who have contributed to the appearance and success of this finished book — typesetters, designers, production editors, printers and many more. To these unrecognized but essential men and women, my deep admiration and appreciation for jobs well done.

I would also like to thank my many students, past and present, who make a life in art worth living.

And last, but certainly not least, I would like to express my gratitude to five colleagues whose approach to water media is as valid as it is varied, not to mention exciting: Dorothy L. Angeli, John C. Bierley, David M. Hopkins, L. Maile Marshall and Ed Steinhilper. These fellow artists and good friends have graciously allowed me to use their work to illustrate this book. I can truly say that without them there would be no book! Thanks a million to all of you!

Table of Contents

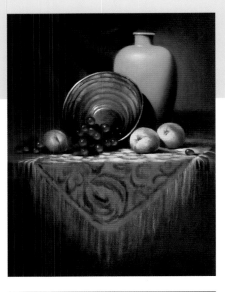

INTRODUCTION . *page 8*

CHAPTER 1

Value: The Foundation of Form and Drama

Instructive illustrations and minidemonstrations depicting objects' forms, dimensionality and spatial relationships • Optical illusions caused by The Law of Simultaneous Contrasts • Comparisons and examples demonstrating the inherent drama of strong value contrasts *page 10*

CHAPTER 2

The Value of Light and Shade

Using values to depict light intensity or weakness • Characteristics of light sources and their effect on form, texture and shadows *page 22*

CHAPTER 3

Stay on Course With Value Maps

Using thumbnail sketches and underpaintings to map out values and composition • Overpainting black-and-white or monochrome paintings in full color . *page 34*

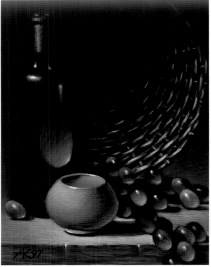

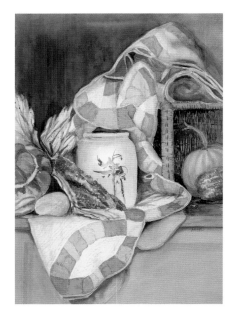

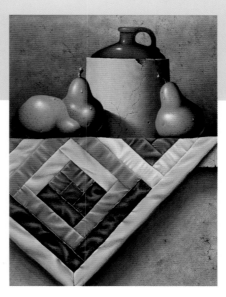

CHAPTER 4

The Value of Color

Overview of value's relationship to color with an emphasis on light vs. bright and dark vs. dull • Color and value charts and comparisons of simply painted subjects illustrating the previous principles • Black-and-white underpainting developed step by step in full color *page 58*

CHAPTER 5

The High Value of Correct Values

The fear of contrast factors • A closer look at how value relates to color, with visual proof that correct values are more important than correct color • Introduction to the phenomenon of interchange *page 80*

CHAPTER 6

Taking Valuable Corrective Measures

A grab bag of fix-it tricks • Keeping light consistent • Revision demonstrations showing how to reevaluate a lackluster image and add impact by adjusting values • Living with a failure . *page 94*

CHAPTER 7

Composing a Painting With Values

Using lights and darks as tools to draw the viewer into a picture • Using values to suggest movement through space. *page 108*

CONCLUSION . *page 124*

INDEX . *page 126*

Tangerines, Alex Kedzierski, 14"x 18¹/₂"(36cm x 47cm)
Oil on canvas mounted to board
Collection of Elaine K. Hacker (photo by Donald J. Nargi)

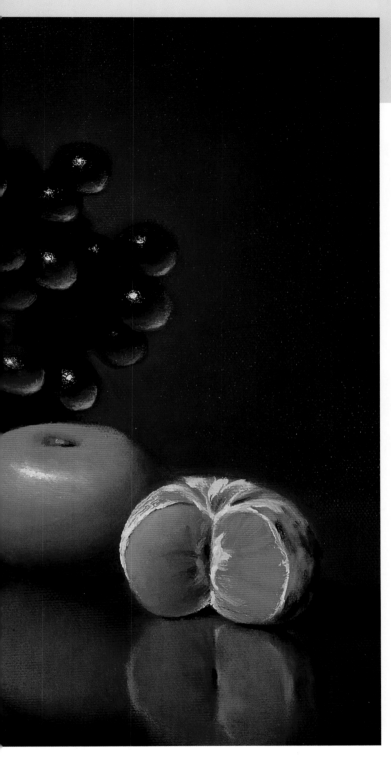

Introduction

If you are like most people, myself included, one of the first things you probably notice when you look at art is color. In fact, that may be the only thing you really observe. You may be aware of the subject matter or compositional influences, but unless you have been "into" art for a while, you may not take a close look at the artists' uses of tonal values. And though that is perfectly natural, I hope to change that by the end of this book. In fact, I hope to make tonal values and their immense impact on a picture the very first thing you notice when you look at a piece of art. As you will see in short order, values are the single most important element in the depiction of visual images. Without at least minimal contrast showing light and dark values, even the brightest of colors will appear flat, one-dimensional and boring.

On your journey through this book, I will show that the subject of tonal values is composed of elements other than the obvious light vs. dark relationship that most people use to define values. Many optical illusions are the result of varying degrees of tonal contrast, and when value contrasts are combined with color, the challenges really get to be fun!

You will find some facts repeated throughout the text. This is not because I was lazy, or to serve as a filler, but because different phrasing of the same information in different contexts may "ring a bell" more readily for you. With so many important aspects of value to be considered, each new reminder acts as a subliminal message, eventually finding its mark and making its point.

In addition, I also make references to material covered in earlier chapters. This is my devious way of getting you to review some of the tenets put forth and to make good use of the information contained within these pages. So, having been warned, why not forge ahead?

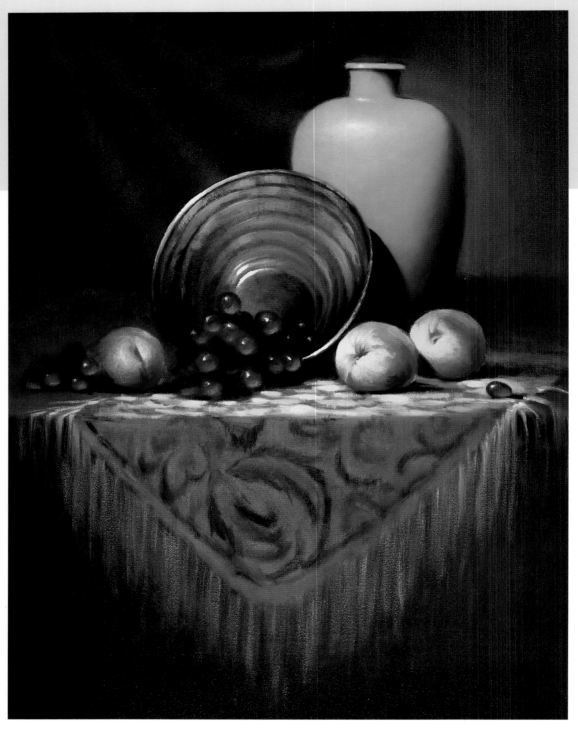

Although a very strong composition and exciting use of color first grab our attention in this piece to the left, it is the strong contrasting values, used to show off each element in the painting to its best advantage, that really give the painting its impact and help hold our attention. No matter how strong the composition or how brilliant the color, weak value contrasts would still diminish the picture's overall strength.

Celadon Vase With Peaches, Alex Kedzierski, 28"x 22"(71cm x 56cm), Oil on canvas
Collection of Frank and Nancy Sweitzer (photo by Donald J. Nargi)

Value: The Foundation of Form and Drama

Value is simply the relative lightness and darkness of either a color or tone of gray. The operative word here, however, is relative, because all values are influenced by their adjacent or surrounding values or tones. For example, how light or dark is a red apple? That question cannot be answered without first asking, "In relation to what?"

The importance of correct value relationships cannot be overstated. It is a primary factor in depicting form and in generating visual excitement. Value can (and often does) stand on its own and has no real need for color. Just think of all the black-and-white images in newspapers, magazines or old movies. Even without color, these images often pack a powerful punch. We can readily identify celebrities, recognize spatial depth and even get a sense of the quality or type of light (day or night; sunny, overcast or stormy; electric, candle or firelight; and so on).

To introduce the study of value, I will use mostly black, white and shades of gray to illustrate some of the many optical illusions that you will encounter in painting, not just so you know they exist, but so you can exploit them in your own work for greater dramatic impact. At the end of this chapter, I will introduce color and illustrate the importance of value as it relates to color.

THE GRAY SCALE

The nine-step gray scale pictured here is standard. It runs from black (step one) to white (step nine), and has seven steps of intermediate grays in between. Step five is considered a middle value. However, the middle-valued horizontal strip appears to be lighter in value at the low, or dark, end of the scale, and darker at the high, or light, end. This phenomenon is known as The Law of Simultaneous Contrasts, which states that any given value ap-

pears darker than it actually is when place next to or surrounded by a lighter value, and will simultaneously look lighter when it is adjacent to or surrounded by a darker value. It is most noticeable between steps, which appear to change value at each of the edges where they meet. This is what is sometimes referred to as the louver or Venetian blind effect. If this is difficult for you to observe, try squinting slightly.

Looking at the gradated strip below, notice how it appears to

grow wider as it moves from black to white. It is important to be aware of this apparent contraction of dark values and expansion of lighter ones. A perfectly measured and drawn outline of a symmetrical object (a vase, bottle, stemmed glassware) may appear asymmetrical or lopsided when a body shadow is added. There will be times when you may need to intentionally paint a distortion in order to make the object appear to be visually correct.

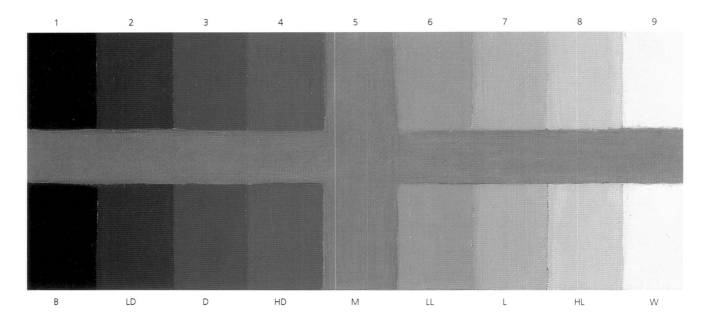

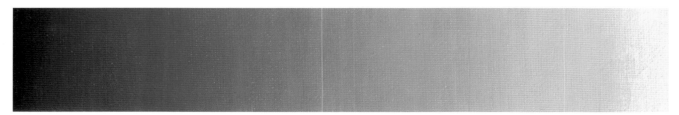

The Gray Scale and Optical Illusions
The standard nine-step gray scale moves from pure black (step one) through seven steps of gray to pure white (step nine). These nine steps also have names, and it might be easier for you to envision a given value if you think of its name instead of a number. They are, from steps one through nine, black (B), low dark (LD), dark (D), high dark (HD), middle (M), low light (LL), light (L), highlight (HL) and white (W).

In the lower strip, the nine values have been softly blended so they gradate from black to white. The dark end of the strip appears narrow, but the strip seems to widen progressively as it moves toward the light side.

USE VALUE TO CREATE VISUAL IMPACT

Form can be depicted and dimension suggested by using only three values, any three values. However, the three values selected are crucial to the overall effectiveness of the finished image. In these six small paintings of an urn, there's a big difference between those painted with very close values and those painted with progressively wider spreads in value.

Close Value Relationships

The first three urns are painted in three value steps that have a close tonal relationship. And though the vase is clearly visible in all three examples, the close relationships produce flat, boring, two-dimensional pictures. I am not suggesting to never paint with close values; in fact, using close values is a surefire way to suggest distant space in a landscape, or weather effects, such as fog or mist. But even in that context, stronger value contrasts are needed in the foreground elements or the painting will be flat and dull.

Greater Tonal Range

The last three urns, again painted with only three values each, are more visually exciting because of greater tonal contrasts. The first urn is more interesting than either of the preceding three merely by virtue of its greater tonal range. The second has even more contrast and impact. The last one, painted with the most extreme range (pure black and white, plus middle-value gray), is the most visually arresting of all. Remember that the lower the contrast in values, the softer the edges appear, even when painted very sharply; the greater the contrast, the harder the edges seem.

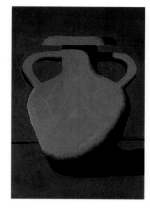 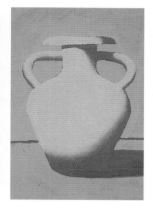 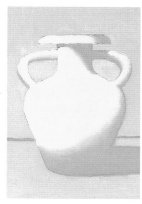

Using Three Values to Show Form
These small value studies show an urn painted in value steps one, two, three (left); four, five, six (center); and seven, eight, nine (right). Although the urn is visible in each piece, the overall impression is flat, two-dimensional and uninteresting due to the very close tonal relationships.

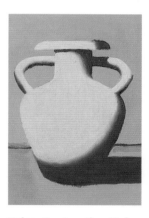

Using Contrasting Values to Add Impact
In these three pieces, painted with value steps three, five, seven (left); two, five, eight (center); and one, five, nine (right), tonal contrast has been progressively stepped up, giving each picture in turn an increasingly dramatic impact.

ADD MORE VALUES TO EMPHASIZE FORM AND DIMENSION

Though an accurate representational image results from using just three values, a much greater sense of volume and stronger suggestion of dimension are achieved by adding just two more values to the subject, in this case the same vase. Also, manipulating the values on the tabletop and background adds variety for visual interest and emphasizes the vase itself, which is what the painting is all about anyway.

Use Five Values for Maximum Interest

My use of values is not arbitrary or capricious. It is dictated by the need to show off the vase to the best advantage. For example, I graded the background slightly from dark on the left to a little lighter on the right to aid in defining the light side of the vase on the left and the shadowed side on the right. Similarly, I painted the horizontal plane of the tabletop with gradations of light and dark values precisely placed to further enhance the vase's form.

To further develop the vase, I added bright highlights and, to suggest even more dimension and roundness, reflected lights in the body shadows both under the handles and along the lower right edge. These reflected lights separate the handles from the background, and the bottom of the vase from its cast shadow on the table. Although this piece was painted in a rather exaggerated manner (it looks more like a value map, to coin a phrase, than a painting), it clearly shows the need for controling which values you choose to employ and where you choose to place them.

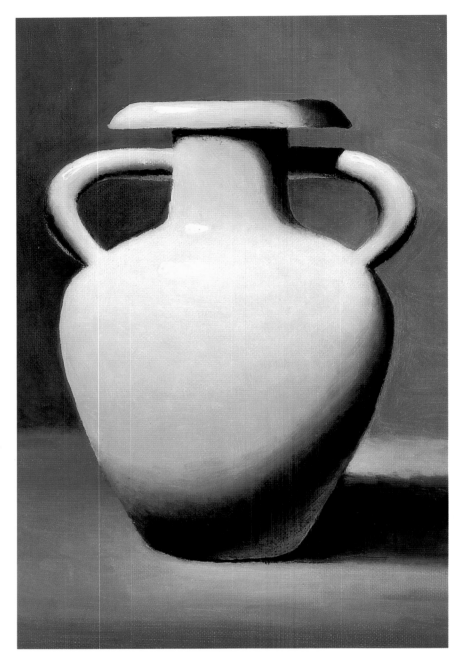

Add Two Values to Increase Dimension

In this version of the vase, strong highlights of pure white were added to the urn's body tone, handles and lip at the top, and reflected lights were painted into the body shadows under the handles and along the right edge. This helps separate the urn's shape from its cast shadow on the table and projects the urn forward into space. A thin line of black (known as the proximity shadow) added to where the bottom of the urn meets the table establishes the fact that the urn is gravity bound and not hovering in space, ready to take off. The gradated values in the background and on the tabletop are painted so as not to compete with any body lights, body shadows or reflected lights anywhere on the urn.

BACKGROUND AND SUBJECT VALUES

Now, get back to that red apple mentioned at the beginning of this chapter: How light (or dark) is it? The answer depends on what values surround or are adjacent to it.

Altering Background Values

In the first two examples, the apples are painted with the same middle value, neither particularly light nor dark—just somewhere in between. But when seen against its background, the first apple appears darker than we know it actually is, while the second one looks relatively lighter. Of course, since everything in painting is relative, this difference is noticed only when both pictures are viewed together. Seen separately, each apple will look like a middle-value gray placed within a light or dark situation.

Altering Subject Values

In the second two examples, the backgrounds are painted with a middle value, while the apples are painted darker or lighter. When seen against the corresponding apple, the backgrounds seem lighter or darker than they actually are. Painting dark against the middle value gives a sense of the apple's true red color, even in a black-and-white depiction. The lighter version, however, suggests the light yellow or green of a golden delicious or Granny Smith apple.

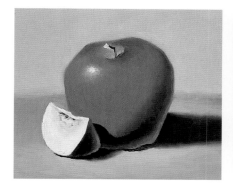
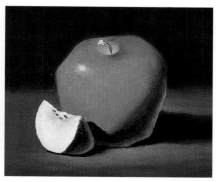

Both of these "red" apples are painted identically in a middle-value gray. The apple at left is surrounded by a fairly light value, so it appears darker than it actually is. In the illustration on the right, however, the same apple looks lighter in the darkened atmosphere of its surroundings.

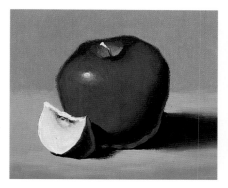
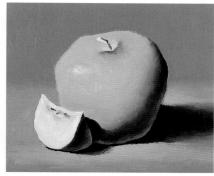

In these two illustrations, the background has been painted in a middle value. In this case, the subject matter must be painted darker or lighter than its surroundings for it to be clearly visible. The first of these illustrations shows a dark apple against a relatively light background, while the second depicts the apple as light against a relatively dark background. However, the lighter apple would never pass for a red apple.

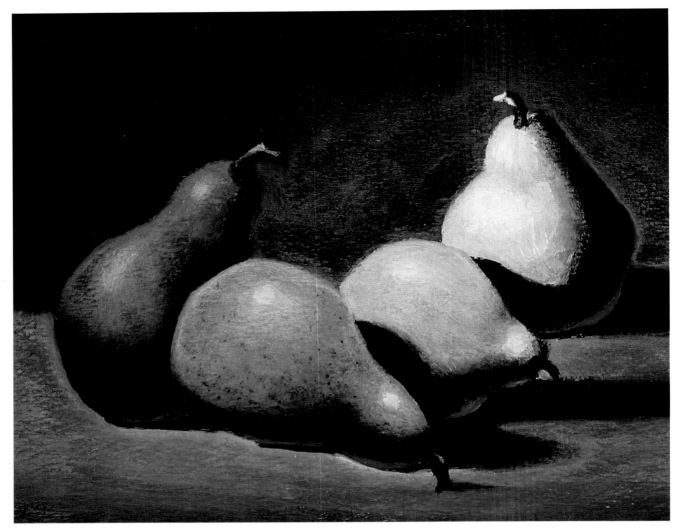

USING THE FULL RANGE OF VALUES

By using just three contrasting values, it is easy to suggest form with paint. By going one step further and using five values or tones (call them the body tone, the body shadow, the cast shadow, the highlight and the reflected light), it is possible to paint a pretty convincing depiction of the form's volume and dimension.

But what about the seemingly infinite number of values we really see? Forget them! We really do not see as much as we think we do unless we consciously focus on what we are observing. Attempting to premix each minute shift in value would be extremely time consuming. Using an infinite number of values would reduce contrast where needed and would diminish the overall impact of the painting.

Keep It Simple

It is best to work with a maximum of five values and allow subtle shifts to occur automatically in those areas where subtle blending of edges are used. Avoid the temptation to blend a passage to death. Overblending flattens an image by spreading the transition of one value into another, thereby reducing the contrast and weakening the impact.

Using the Full Range of Values
Although shape and size tell a great deal about the fruit in these two pictures, it is the value, not the color, of each piece of fruit that defines it as a bosc or an anjou pear, a lemon or a lime. Each piece of the fruits varies in its own overall value (a dark bosc pear vs. a light anjou, or a dark lime vs. a light lemon), yet each fruit is painted in five recognizable values (body tone, body shadow, highlight, reflected light and cast shadow), giving it a feeling of roundness, volume and dimension.

In both pictures, the background material (the wall and tabletop) is painted with smoothly blended gradations of values. These seamless transitions from light to dark (or vice versa) remain inconspicuous and unobtrusive, allowing the subject matter to dominate the paintings.

In the two illustrations on pages 16 and 17, each of the pears and citrus fruits, although of different colors, is painted with only the five values of the tones named on page 16. Granted, there are minor variations within each (particularly in the lights), but these small value shifts are intentionally painted to avoid a flat, posterlike appearance and to suggest some texture. Also, there is very little blending where the light on each piece of fruit falls off and rolls into shadow. The cast shadows are sharp edged at their points of origin but become more and more diffused around the edges the farther they move from the objects casting them.

The background material (the back wall and tabletop) is painted with very soft, extended blends that produce a seamless, almost invisible transition from dark to light. It requires a conscious effort and active looking to see these passages. Why? Because they are smoothly painted, with slow gradations from one value to the next (no abrupt value shifts to catch the eye) and with a rather limited value range so that they remain unobtrusive. Rather than draw attention to itself, the background's role is to support and even enhance the foreground passages (the subject matter).

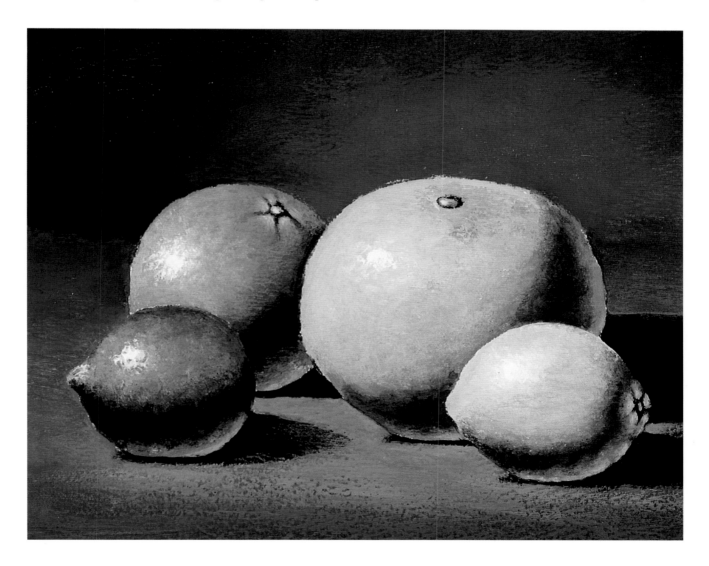

VALUE CONTRAST VS. COLOR CONTRAST

It is easy to see value or tonal contrast in black and white. But since we respond more readily to color and can easily distinguish two contrasting colors placed side by side, we have trouble seeing their values or tonal relationship. A large yellow rose silhouetted against a clear blue sky of the same value, for example, might be visually exciting in color, but in black and white, it would appear as a nearly uniform gray tone.

The checkered squares illustrated here in both color and black and white show how lowering the value of one or the other of the colors affects the contrast between the two colors. In the first chart, the colors are of similar values. Squinting at the chart blends these two optically jarring colors blend into a monotonous gray. In the black-and-white photograph of this chart, the two close values are dull when placed side by side.

Study the remaining color charts on the next page and their accompanying black-and-white reproductions to see how easily and effectively those charts can be made more tonally exciting by altering just one value.

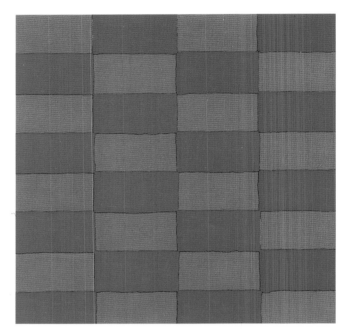

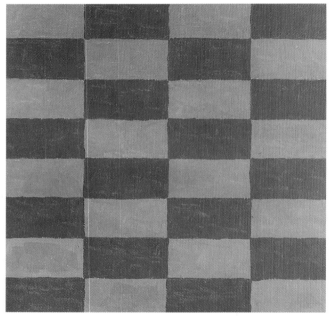

Contrast: Value vs. Color
In this red and green checkerboard, it is easy to see the contrast between the two complementary colors. However, because of the close values of the two colors, squinting at the checkerboard causes a merging of all edges, giving the impression of a uniform value. This is especially apparent in the black-and-white photograph of the same checkerboard, which clearly shows how the close values produce a flat, boring image.

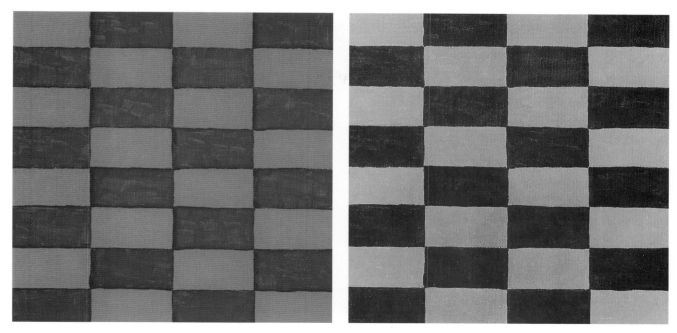

Combining Color and Value Contrast

Darkening one color (green in this instance) enhances the contrast of the two complementary colors and strengthens the contrast in the value relationship. In the unfiltered black-and-white photograph of this chart (at right), the strong value contrast is still very obvious.

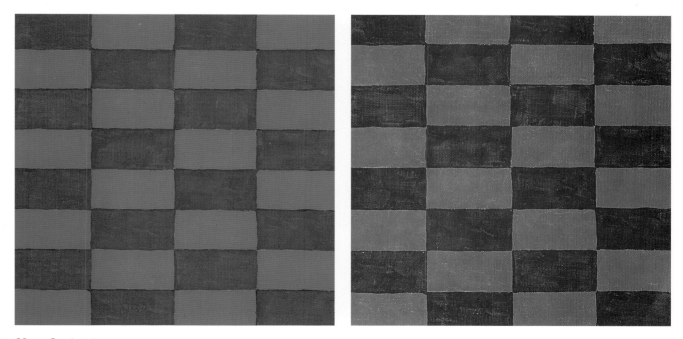

More Contrasts

Here, the red areas were darkened. Once again, both the color and the value contrasts are obvious. The accompanying black-and-white photo also clearly shows the contrast in values.

SUMMING UP

This is not a workbook. There are no suggested activities or planned projects for you to complete. However, painting two or three simple sketches in black and white could not hurt. They do not have to be elaborate compositions with dozens of objects. A no frills setting with a single vegetable or piece of fruit, a single cup or teapot (you get the picture) is more than enough to serve the purpose. I guarantee you will have fun and gain an enormous amount of insight into value and how to use it effectively. To experiment a little with color, prepare three charts in red and green, using only four squares per chart (two red and two green squares) to keep it simple. Do the first with equal values of red and green, and do the second and third charts by lightening first the red and then the green rather than darkening them as I did in my examples. Make it even easier by using colored pencils or crayons.

If you are feeling adventurous, do more charts using different contrasting color pairs. Just remember to paint the first chart of each set with as close to identical and middle values as possible. Squint at the charts to see if the colors combine to make an evenly spread value pattern (as they will if the values are close), or if they separate into a distinct light and dark pattern (as they will if there is sufficient contrast in values). In fact, go back to the small urn paintings on page 13 and squint at each of them. The difference between weak and strong value contrast should be obvious, even through half-closed eyes. Then do the same with the apples on page 15 and see how well the images hold up.

REMEMBER:

- Any given value looks darker than it actually is when placed next to or surrounded by a lighter value than itself, and it simultaneously looks lighter when adjacent to or surrounded by a darker value than itself.
- Light values appear to expand and grow larger, while darker values appear to contract and decrease in size.
- The lower the value contrast, the softer the edges appear. The greater the contrast, the harder the edges.
- Lower value contrasts produce an apparent recession into space. Higher contrasts project an image forward, bringing it closer to the viewer.
- By using only five values (body tone, body shadow, cast shadow, highlight and reflected light), an artist can convincingly depict an object's shape, volume and dimension.
- Avoid the temptation to blend a passage to death. Overblending flattens an image by spreading the transition from one value into another, thereby reducing the contrast and weakening the impact.

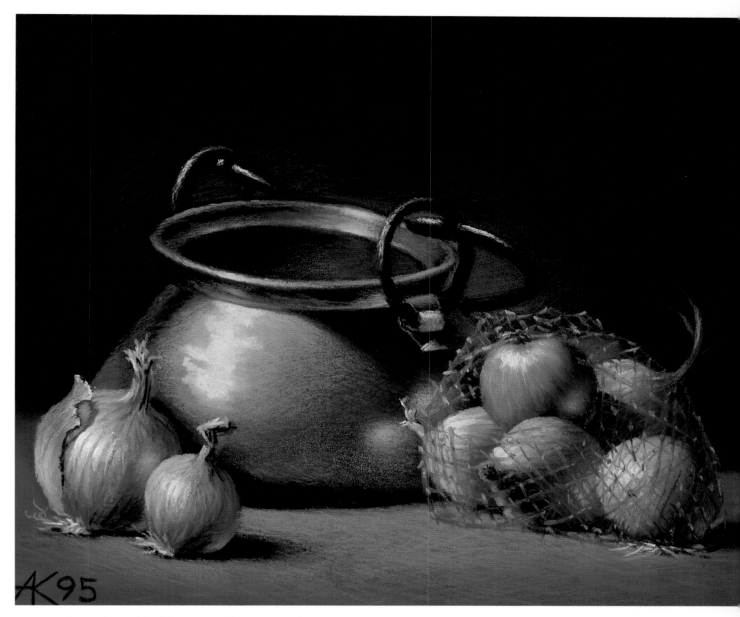

Copper/Onions , Alex Kedzierski, 11"x 13½"(28cm x 34cm)
Pastel on extrafine-grit Ersta-Starke sanded paper
Collection of the artist (photo by Donald J. Nargi)

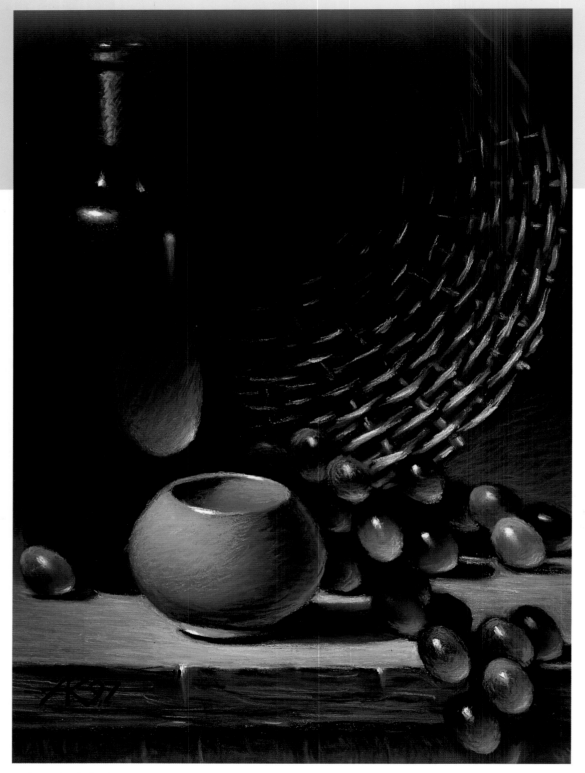

A Flash of Cobalt, Alex Kedzierski, 11¹⁄₂″x 8 ¹⁄₂″(29cm x 22cm)
Pastel on Sennelier La Carte pastel card
Collection of L. Maile Marshall (photo by Donald J. Nargi)

The Value of Light and Shade

When I think of light and shade, as I do when I think of any two words that have opposite meanings — for instance, bright and dull, hard and soft, warm and cool, thick and thin — I think of contrast.

Whenever we look at something, our brains process the information in such a way that the easiest areas to see are the only areas we pay attention to. So we take notice of the light and virtually ignore the shadows. We are drawn to bright color and do not readily take notice of the dull. Similarly, we readily recognize a sharp or hard edge and ignore a soft, out-of-focus area.

This perfectly natural and instinctive preference for seeing only those things that are the strongest elements is, I am convinced, the major cause of weak work produced by virtually all beginning artists. But artists must learn to look beyond the obvious and the easy. They must learn to simplify the difficult! Only by learning to observe, recognize and use all of the visual information that is available to us can we produce variety — an essential ingredient in good artwork.

In this chapter, we will continue the investigation of values in black and white, with particular emphasis on body shadows, cast shadows and how to best use values to depict a convincing sense of form and texture.

With the exception of the brilliant blue of the bowl and its distorted reflection, color plays an extremely minor role in this painting, but the interplay of both high and low value contrasts is of vital importance to the overall effectiveness and dramatic impact. Weak tonal contrast is very important in depicting the near invisibility of the bottle on the left and the shadowy contours of the basket in the background, while stronger contrasts propel other objects forward into space.

LIGHT AND DARK VS. LIGHT AND SHADOW

To the artist, light has two distinct meanings: It can be that which illuminates the subject matter and allows the artist to see at all, or it can be the high value of a color or gray tone. Likewise, dark could suggest either a dark-colored object or an area in shadow. The light source (illumination) and light values, as well as shadows (an absence of illumination) and dark values, appear simultaneously in almost everything an artist draws or paints.

Light Sources

Basically, there are two forms of illumination, or light sources: natural light, which includes daylight, firelight, candlelight and even moonlight; and artificial light, either incandescent or fluorescent. Within these types, there are many variations to deal with, including the "temperature" of the light's color. For example, daylight can be bright and sunny (warm, influenced by yellow), or dull and cloudy or overcast (cool, influenced by blue-grays and other neutrals). In fact, on a start-to-finish clear day, the color of the light outdoors can run the gamut from a rich red-orange in the early morning to a deep blue-violet at day's end.

When dealing with artificial light, remember that incandescent lightbulbs are almost always warm and can range from yellow to yellow-orange, depending on the wattage. Fluorescent bulbs on the other hand are always cool and can be found with bluish to greenish and even cool pink qualities.

Light Intensity

Illumination can be hard and intense (sunlight, a halogen spotlight), or soft and diffused (overcast, fog, mist, a floodlight). More than any other factor, the intensity of the light source determines how texture, light and, particularly, shadows are depicted.

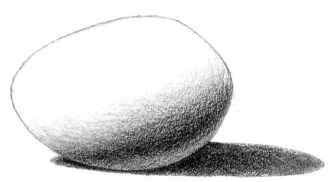 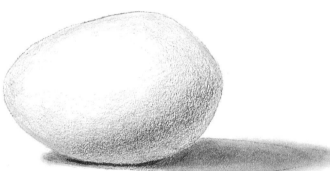

The Effects of Light Intensity

Strong, intense light is depicted with strong value contrast. The egg on the left shows the effect of "burnout" on its light side. An abrupt move into the body shadow, which is quite dark even though it is on a white object, and a very strong, dark cast shadow are also typical of the effects of strong light. The egg on the right illustrates how diffused lighting produces much less tonal contrast. The diffused highlight is surrounded by lighter values, which show more of the egg's form and smooth texture and move more slowly and softly into the body shadow, which is noticeably lighter than the one on the left. The cast shadow is also somewhat lighter and becomes diffused with progressively softer edges as it moves away from the egg.

Shadows

There are two types of shadows to deal with, and both are caused by an absence of light falling on a given area. The first is the body shadow, or the area on a three-dimensional form that faces away from the light source and cannot receive illumination. The second is the cast shadow, a condition caused by an object (usually opaque) that blocks the passage of light. For instance, an apple will cast its shadow along the surface it is resting on, up a nearby wall or onto another object positioned closely enough to be affected by the apple's cast shadow.

Light Values

Light, as it applies to values, usually means a light color or tone. The sky, for example, usually has a lighter value of blue than do blueberries. However, since we can only see when a source of light illuminates our world, all three-dimensional objects will have a light side (the area facing the light source) and a dark, or shadowed, side (the area opposite the light source). The amount of contrast between the light and shadow sides may vary because of the light source's intensity, but there will always be a light side, even on a black object. Yes, even if you think it is an impossibility, you must paint light and dark black!

Dark Values

A dark value can suggest either a shadow or the basic dark color of a specific object. A glass of red wine has a darker value of red than a pink carnation, for example, and both have a light and dark side. And, as with the problem of painting a light and dark side for a black object, dark values are needed in the shadow sides of all white objects as well. In fact, the shadow side on a white object can be much darker than the light side on a colored object — even a fairly dark colored object!

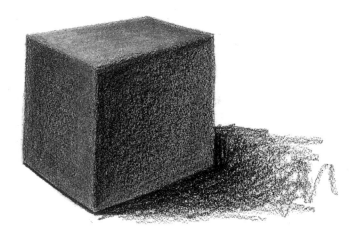
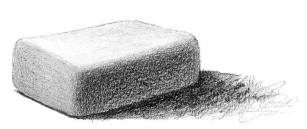

Planes and Edges

Painting the black cube on the left with only black paint would result in only a silhouette of its shape. The three visible planes of the cube must be painted with three different values, even if those values are very close. Also, neither of the sides is a single, solid tone; there are subtle gradations in each of them. With the bar of soap on the right, the same rules apply: three planes, each with its own recognizable value and each value having some visible gradation. The corners and edges of the soap are rounded, so the transitions from one plane to another must be done with soft, rounding blends.

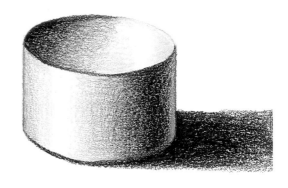

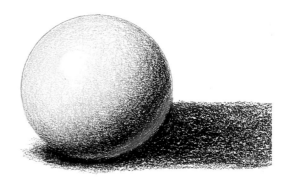

THE EFFECTS OF LIGHT AND VALUE ON FORM AND TEXTURE

As stated earlier, the amount or intensity of light falling on an object dictates how the intensity of shadows is depicted and the amount of visible texture on the object.

Form

There are two ways to show form: Draw the object's contour or outline, which is a linear approach, or mass in light and dark values to get a sense of the object's volume or dimensionality. While the linear drawing may certainly look like the subject matter, the massed version of the same object shows form that has weight and dimension and occupies space.

In fact, even without an outline, and with only one value (the body shadow), both a form's shape and dimensionality can be depicted quite clearly and convincingly, proving that shadows describe form (this is almost certainly the reason most artists working in opaque media work from dark to light, striving to get strong shadow patterns down almost immediately to give a sense of gravity-bound, voluminous objects existing in space).

Using Values to Describe Form

The contour or outline of an object is flat and two-dimensional, even when filled in with a single value color or gray tone (the square and circle at left). When values are gradated, however, a feeling of volume and dimension begins to emerge. The flattened shapes of the square and circle take on a cylindrical and spherical appearance (center pair). Move the frontal, head-on light source to the upper left, add highlights, reflected lights and cast shadows (and change the top and bottom edges of the square to ellipses), and the illusion is complete — a convincing depiction of solid, three-dimensional objects that occupy space (pair at far right).

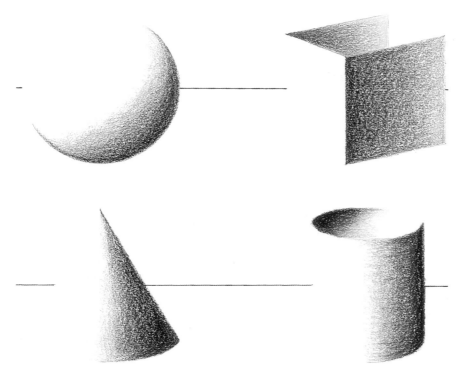

Value Alone Can Show Form
Even without the contour lines to describe an object's shape, a well-placed, single value can convincingly portray form. In the four geometric shapes shown here, the only values used to represent these shapes are the body shadows. Yet each form is clearly visible in its entirety, not because we are familiar with these particular shapes, but because we normally interpret what we see in terms of volume and mass (which is the result of seeing light and dark values) rather than outlines or silhouettes.

Texture

At its simplest, texture can be defined as either a smooth or a rough finish over the surface of an object. Yet there are a vast number of textural variations between those two extremes. What is even more difficult for artists is that textures are often described by their tactile qualities (the sense of touch) rather than by visual properties.

For instance, a rock or stone can be visually smooth or rough, round or angular, with cracks, nicks, bumps, dents or pits, yet it is always hard. A sponge can exhibit many of the same textural characteristics as a rock, but it is always soft. Swiss cheese has a waxy-looking texture, while Brie looks creamy. Dried flowers and dead leaves appear brittle, but onion and garlic skins have a papery texture. Glass and china are always hard and usually smooth; however, either may show texture (etching or "cut-work" on the glass, raised or incised designs on the china), and either may be shiny, matte or somewhere between the two and have a semigloss or lusterlike appearance. Most metals share the same attributes as glass and china, and when polished, they are highly reflective as well. When tarnished, and depending on the degree of tarnish, reflections can run the gamut from subtle to virtually nonexistent. The textural list can be virtually endless. But take heart. Artists have always been and will always be able to meet the many challenges that drawing and painting textured surfaces brings.

Light and Texture

Since light is energy, and pigment, whether it is graphite, charcoal, ink, wax or paint, is inert, an artist can only hope to suggest the effects of that energy on the subject matter. The whitest white paint could not get me to blink even once. But an overcast or downright stormy gray sky can provoke a bout of squinting to the point of migraine. That is because each tiny droplet of moisture in the atmosphere is suffused with the sun's radiant energy. Unable to pass through the cloud layer, the rays of sunlight are reflected and refracted by the atmosphere, dispersing light across the whole of the sky until all that is seen is a mass of blinding energy.

On a very clear day, however, it is possible to stare up at the sky and into deep space for hours with no discomfort. (Don't try looking directly at the sun, however!) Even a deep blue sky is more brilliant to see than the whitest pigment. In fact, even moonlight's weak radiance is more energetic than any pigment.

What I am getting at is this: We cannot paint light, so we must accept the limitations of our medium, whether it is pencil, pen or paint, and try instead to depict the effects of light as it falls onto and travels across the surfaces of our subject matter.

Value and Texture

Using values to show texture is simply a matter of identifying whether a light source is basically intense or diffused and then acknowledging a few facts of life about the effects of these light sources on the subject matter. It is also a fact that all form is composed of planes that face the light and planes that face away from the light.

When the light side of a form moves abruptly into shadow, showing a sharp edge between the two planes, a cube or pyramid is visible. Conversely, when a light plane rolls into shadow with a soft blend, an impression of roundness results (depicting a sphere, cylinder or cone). The softer the blend and the slower the movement from light to dark, or the wider the spread of the halftone between light and dark, the rounder the form. A block of wood and a telephone directory could both be sharp edged, but dice or a bar of hand soap, even though cubical in form, would have both flat planes and rounded edges that should be indicated with more gradual transitions from light to dark.

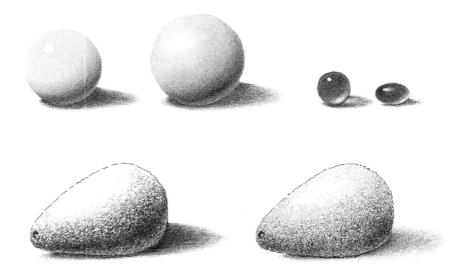

Using Values to Describe Texture
In the top row of round objects, the smoothly blended transitions from light to dark suggest smooth surfaces. The hard-edged specular highlight on the upper far left sphere, as well as the more abrupt move from light into shadow, indicates a highly reflective or glossy finish and usually, but not always, suggests a hard object, such as a cue ball. A highlight that spreads out in soft diffusion, as well as a wider spread of the halftone value between light and shadow, suggests a softer surface and a matte finish, such as that on a child's pink rubber ball.

Body shadows are at their darkest at the edge farthest from the light source and/or next to a reflected light. When seen adjacent to reflected light, this dark value is often referred to as the core of the shadow. Be careful to keep reflected lights fairly dark and subdued. Since its primary function is to separate body shadow from cast shadow, reflected light should be only a whisper. Adding too much into a shadow will make it look like transmitted light (light that passes through a transparent or translucent object and appears on the side

opposite the light source), as with the marble and grape on the top right. Notice how the marble's uniformly crisp, hard-edged highlight suggests a shiny hard surface while the transmitted light on the opposite side, and the core of light inside the cast shadow in particular, tells us of the object's transparency (clear glass or plastic). The grape's highlight on the other hand, hard edge toward the light and diffused as it moves away, convincingly suggests a pearly or waxy texture.

In the two avocados pictured above, the most obvious texture found on them is at the point of transition where light rolls into shadow. Rough texture is less discernible in direct light and is all but lost in shadow passages. In very strong light, texture is virtually burned out but the object retains strong value contrasts in the halftone between light and shadow, as with the avocado on the left. Conversely, in more diffused light, texture is visible over a wider range of the surface area but tonal contrast is also greatly reduced, causing softer, more diffused texture definition, as with the avocado on the right.

LIGHTING CONDITIONS

In showing the effect of light in our work, we have basically two approaches available: We can either show the effects of harsh, bright light or the effects of a softer, more diffused lighting condition. In showing one or the other of these lighting situations, we also show one of two degrees of texture definition.

Intense Light

Very strong, intense illumination has a tendency to burn out both texture and color. What limited observable texture there is can be found in the halftone area where the light rolls into shadow. This texture, if relatively rough or coarse, should be depicted with an equal amount of intensity as the light that produces it by using strong value contrasts. The body and cast shadows are similarly rich, intense and usually very dark, showing no texture at all. This darkness and absence of texture act like complements to the light and textured side of the object. Any reflected light in the shadow side may or may not show texture, depending upon the tactile quality of the actual surface being rendered.

Diffused Light

With softer light, there is less overall severity in the appearance of the subject matter. Visible texture is extended over a broader area but is still most evident in the transition between light and shadow. However, the high value contrast of the texture should be reduced, which diffuses the look of the texture in order to reflect the softer, more diffused lighting conditions. Both the body and cast shadows are somewhat lighter, with softer edges. Once again, depending on the degree of texture, it may or may not appear in the body shadow itself but would almost certainly be seen in the reflected light in the body shadow.

Reflected Light

I want to briefly mention the effects of reflected light bouncing back into body shadows. The intensity of this value (one of five tonal values mentioned in chapter one) is influenced not only by the intensity of the light source but also by the value of the surface causing the reflection. (Reflected light is also influenced by the color of the reflecting surface, but that is another chapter.) For example, subject matter placed on a dark surface (such as a dark tabletop or a dark red or green tablecloth) may not show any reflected light because there is not enough energy reflected off of the dark surface to bounce back. But the same object sitting on a light-colored or white surface could have a great deal of light reflecting back into the body shadow. Let me repeat, however, that reflected light can never be lighter than the value of the plane facing (and receiving) direct light.

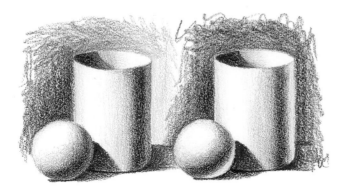

Reflected Light

When light bounces from a nearby illuminated area back into a body shadow, it is known as reflected light. However, this value must be kept low in order for a depiction to be believable. The sphere and cylinder on the left have subtle reflected lights in their body shadows that do not draw attention away from the objects' light sides. On the right, the extreme amount of light in the shadows suggests a secondary light source coming from the right rather than a reflected light. This situation is implausible because a second light would drastically lighten all the shadows, as well as cast additional shadows of its own in the opposite direction. Another disadvantage of too much reflected light is that the artist is forced to use a uniformly dark background, so as not to lose the cylinder's right edge, rather than a visually more interesting gradated background, as on the left.

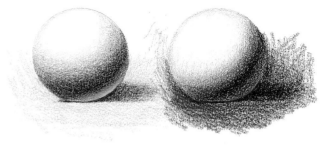

Surfaces Influence Reflected Light

Of course, the value of the reflecting surface also influences the amount of light reflecting back into a shadow. The very light ground on the left absorbs very few and reflects almost all of the light rays striking it, so there is more radiant energy available to be absorbed into the shadow. However, reflected light can never be as high in value as the light side of the object. On the right, the darker ground absorbs almost all and reflects very little of the light, so there is less light available to bounce around.

CONCAVE VS. CONVEX

Tonal values are used to describe concave and convex movement in and out of space. Neither line, edge handling nor color can depict these two spatial qualities. Concave form moves inward and usually recedes into space. It is also known as negative form because it occupies the interior of geometric forms such as empty boxes (cube), cans (cylinder) or cups and bowls (half spheres). Positive form is just the opposite: the exterior bulges of cubes, cylinders or spheres. Being convex, those shapes move outward or are projected forward into space. Simply stated, since light cannot bounce back into a cast shadow, the absence of a reflected light in a shadow suggests a concave condition, but since light can and often does bounce back into a body shadow, the inclusion of a reflected light in a shadow suggests a convex form.

To suggest a concave appearance, place the darkest shadow tone along the edge closest to the light source (this is the cast shadow inside the concavity). Then place the lightest value on the opposite edge — the edge that is farthest from the light source (this becomes the highlight). To depict convexity, reverse the process to show the object's body light (not necessarily the highlight value) at the edge closest to the light source, then add the body shadow's tonal value along the opposite edge. Finally, add a reflected light to the body shadow, starting at the edge and blending softly inward to produce the characteristic core of the body shadow. This reversal of light and shadow patterns is characteristic of the concave/convex relationship. A concave shape is immediately recognizable because its shadow side is nearest to the light source and its light side is opposite or away from the light source.

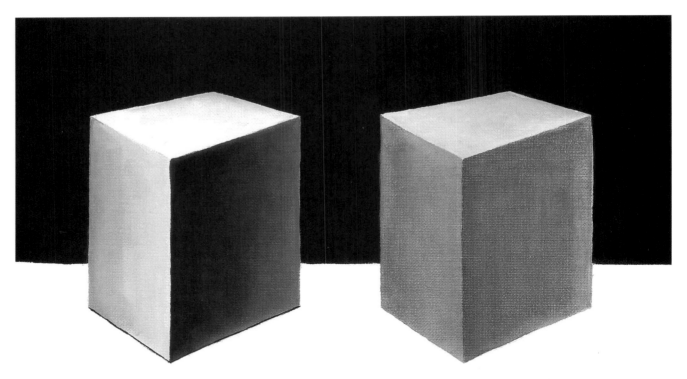

Values and Spatial Relationships
These two blocks are the same size and occupy the same location in space, yet the left appears closer because of the higher contrast in values and the right appears to recede into space due to its closer values. As always, the higher contrast exaggerates the hard edges, whereas the lower contrast suggests an overall impression of softness, even though all of the edges on both blocks were painted with the same degree of sharpness. (For some reason that I cannot explain, all of those illusions seem exaggerated when the picture is upside down!)

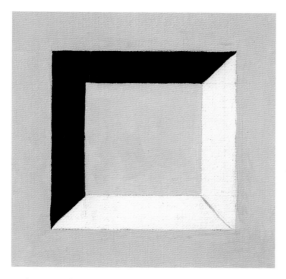 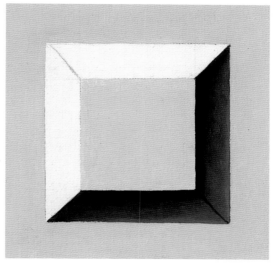

Values and Concave/Convex Relationships

With the light coming from the upper left and raking across the surface of the left-hand image, it creates a cast shadow on the top and left-hand inward/downward slopes of the shallow depression. The light source simultaneously highlights the bottom and right slopes. It is important to remember that there is no reflected light bouncing into the shadow of a concave shape or space. On the right, the light and shadow passages are reversed and a subtle reflected light was painted into the body shadow, all of which suggest a raised surface, with the sides sloping outward or upward from the base. A convex form almost always shows reflected light in its shadow, which also promotes the illusion of the form's volume and dimension.

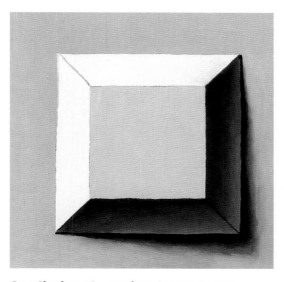 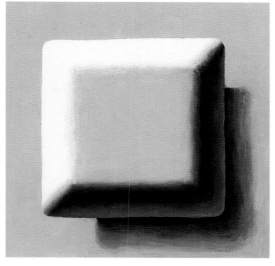

Cast Shadows Strengthen Convex Forms

In this pair, the illusion of solid form projecting forward into space is strengthened by the inclusion of a cast shadow on the left-hand image. On the right, corners and edges were rounded off as shown by the more gradual transitions from light to dark, and the object appears to float in space. This is suggested by the somewhat disconnected cast shadow. This object could be interpreted as a knob on a drawer or cabinet door.

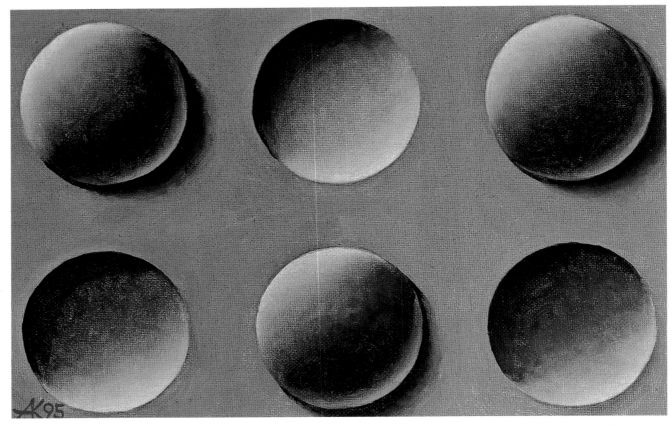

By now, it should be easy to differentiate between the alternating convex "mounds" and concave "holes" in this painting. Hint: The light is coming from the upper left.

Convex/Concave, Alex Kedzierski
8"x 12"(20cm x 31cm), Oil on canvas
Collection of Rob Pierce (photo by Donald J. Nargi)

REMEMBER:
- A bright dark color grabs our attention faster and holds our interest longer than a dull light color.
- The shadow side of a white or light-valued object can be very much darker than the light side of a colored or dark-valued object.
- The intensity of light dictates the way the intensity of shadows is depicted and the amount of visible texture.
- Shadows describe form.
- Very strong illumination can burn out texture.
- Reflected light is influenced by both the light source and the surface from which the reflection emanates.
- Reflected light is never as light as the value of the light side of an object.
- A concave shape is immediately recognizable by the fact that its shadow side is nearest to the light source and its light side is opposite.
- The absence of reflected light in a shadow suggests a concave form, while the inclusion of reflected light in a shadow suggests a convex form.

Po Mo, L. Maile Marshall, 12"x 11"(30cm x 28cm)
Watercolor with Chinese white on rice paper mounted to gold leaf panel
Collection of the artist (photo by Donald J. Nargi)

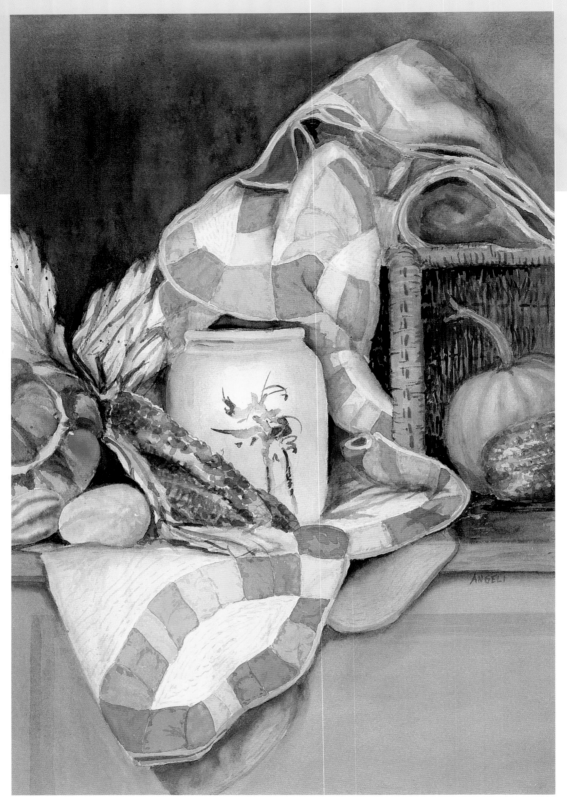

Still Life With Quilt, Dorothy L. Angeli
18³/₄"x 13"(48cm x 33cm), Watercolor on paper
Collection of Alex Kedzierski (photo by Donald J. Nargi)

Stay on Course With Value Maps

Value maps are images the artist makes to establish values for a picture before actually starting the picture itself, particularly if it will be in full color. These maps can be done as thumbnails; as larger preparatory sketches done in pencil, charcoal, pen and ink, markers or even pieces of cut or torn black, white and gray paper pasted or taped into position; or as underpaintings on the surface the artist is planning to paint on. They can be loose and suggestive, or they can be more fully developed, even to the level of photo-realism. However they are created, value studies should give an immediate sense of value distribution and balance — something that is not always easy to see and keep under control in color.

When executed in a single color plus white, these value maps are called monochromatic (one color). When they are done in black and white, they are known as grisailles. Since black, white and gray are not really colors, a value rendering done in those three tones is considered to be colorless and is also referred to as achromatic.

This chapter discusses many approaches to value mapping in action, including monochrome underpaintings (done with turps-thinned Burnt Umber) taken to their full-color completion, a grisaille done in pastels and then finished with further layers of pastel pigment, and a grisaille done in acrylics and developed in oils. There will also be finished paintings and details of paintings that illustrate key points in the text.

A composition of simple, homely objects is made strong and bold through use of the diagonals that define the space, a wonderful balance between light and dark values and warm and cool colors, and a beautiful use of neutralized color throughout. But what really makes it work is the artist's knowledgeable and intelligent handling of the values. She throws away some passages by using closely related values and color temperatures, but she is boldly assertive where it counts.

THE MANY FACES OF TONAL VALUES

If the effective use of tonal values was simply a matter of differentiating between light and dark colors, as is so often stated, there would be little or no use for this book. Nor do I think that anyone could fill the pages of a book with an endless discussion of just the relative lights and darks of a tone of color. But since so many beginning artists find that working with values is a major stumbling block (as do an unfortunate number of pros, I fear), then it seems crucial to take a close, in-depth look at values and the important part they play in the overall success of a finished picture.

Do Not Let Tonal Values Scare You!

If the thought of a conscientious investigation of values worries you a bit, is intimidating or even boring, then approach your investigation from a different angle. Remember, you have already been introduced to some aspects of values and the optical illusions they are capable of producing, and I think the process so far has been pretty painless.

But the study of values, like the study of edge handling, of color's many properties (hue, chroma, temperature and, you guessed it, value) or of any other technique needed to produce a successful painting, is a necessary evil. So rather than fight it, embrace it! Approach your study of values from the angle that you are gathering information that will benefit you — tools you can exploit in

your pictures to the nth degree. Seen in this new light, what at first seemed a daunting challenge becomes a pleasurable quest. Enjoy the prospect of solving a problem — of meeting a challenge head-on.

Take It Slowly

Bear in mind, however, that there is a lot to be learned, and you will not learn anything by just reading about it, hearing about it, talking about it or watching somebody else doing it. To start learning, you must start doing. The motor skills involved in the physical act of doing something are what finally (and permanently) impress themselves upon your mind, making what you have done a permanent part of your equipment. So use the information gleaned so far.

Quickly review chapters one and two to find other illusions caused by values, and be consciously aware of them as you work. For example, remember that a given tonal value changes its appearance when placed near a contrasting value (either lighter or darker than itself). Confront each aspect of working with values one at a time. Put each of them to work for you. Exploit them, and you will learn them. Remember, the only reason a higher authority had for inventing tonal values in the first place was to provide artists with the enormous and unlimited potential to make their work more exciting. Tonal values have not been put there to lurk in some dark corner of your mind, ready to pounce and thwart your every brushstroke!

Start Small

When you begin to experiment with strengthening values and using them more effectively, please do not attempt to do so on a major piece. Put away that 24" x 36" (61cm x 91cm) canvas for another day. Instead, think small.

No matter what medium you are using, begin by doing small sketches only. Using no more than two objects, brightly illuminated by a single light source to get an obvious light and shadow pattern, draw or paint your subject matter. Concentrate exclusively on rendering strong light and dark values. Values alone should be your concern at this time — forget about composition and accurate drawing or color.

If things go fairly quickly, execute another sketch. Then another. And another. If things go a bit slowly, execute another sketch. Then another. And another. Speed (or the lack thereof) is unimportant. Your objective is to learn to see values, then to use and control them, not to paint a masterpiece.

By not committing to a finished picture, you leave yourself open to experimentation and fun. So experiment to your heart's content. Practice a lot (practice makes perfect). Draw or paint your object(s) twice, once with close values or low value contrast (ugh), and once with very high value contrast or a wide separation in values (wow!). See the difference? Great, isn't it? Have a lot of fun and play with values. Yes! You can learn a great deal through play.

10% gray

20% gray

30% gray

40% gray

50% gray

60% gray

70% gray

80% gray

90% gray

Black

A

B

C

Some Different Mediums

These value patches show three mediums to use for value studies. The top left (A) shows three values done with Rexel Derwent Watercolour Pencils. They are, from top to bottom, Ivory Black 67, Gunmetal 69 and French Grey 70. In strip B, I used Caran d'Ache Neocolor II water-soluble painting crayons. The left sides of both charts were brushed with water. In C, Prismacolor Warm Grey Double-Ended Art Markers were used. The horizontal strokes show the three stroke widths the broad nib end can produce, while the short vertical lines show the fine nib's stroke. These markers are also available in Cool Grey and French Grey, as well as "hot" metallics and varied sets of up to 120 colors.

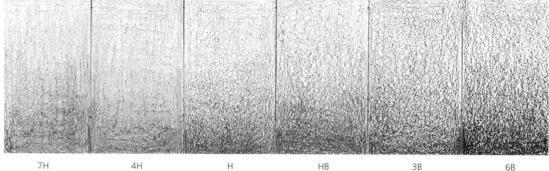

7H 4H H HB 3B 6B

Do Not Forget Graphite

Humble, everyday, run-of-the-mill no. 2 office pencils can also be effective in value mapping. They are inexpensive, and almost everybody has several of them at hand. By varying the pressure, some pretty rich darks as well as very light lights are achievable. Of course, having a few drawing pencils in various degrees of hardness and softness makes the job easier. In the strip above, six different pencils were used with greater or lesser amounts of pressure to get the downward gradation from light to dark. Although the lighter values of each look similar, the feel of these pencils and the sense of control while applying the graphite are what make using them such a pleasure.

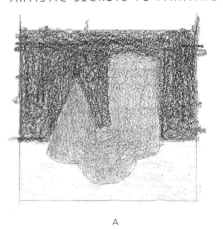

A

B

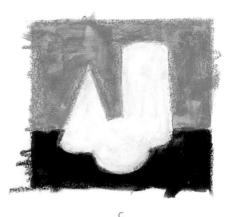

C

D

Different Mediums Produce Different Results

In thumbnail sketch A, the 7H, HB and 6B leads were used to block in the value masses. In sketch B, Derwent Watercolour Pencils were used. With sketch C, I took advantage of the Neocolor II's water-soluble properties and brushed each mass with clear water. For D, I simply used the fine point of a black marker to hatch my middle value and crosshatch my dark tone. The white of the paper was un-touched to represent the light mass.

Creating a Value Map

Ten to fifteen minutes is sufficient time to create a sketch that effectively suggests the placement of all the major light and dark masses, and even subtleties such as reflected lights and highlights. Study the bottom group of four sketches, all done in Prismacolor markers, to see how values are used to emphasize each form's outline and to separate one form from another. Can you see how taking a little time to do a few of these sketches can carry you from the clumsiest beginnings to a refined and exciting ending?

Figure E shows how to narrow the placement of specific value masses for a more finished rendering. For convenience, I am envisioning the geometric shapes in these sketches as being painted in the three primary colors, and the background in simple black and white.

In figure F, I rearranged values to find the strongest impact. But I must decide in advance which arrangement of values will produce the strongest image.

In figure G, I rearranged the elements as well as the values. By bringing the cone forward and placing it in front of the cylinder, I created a stronger image to develop into a complete painting.

Although it is not necessary, the artist could develop a thumbnail sketch using the full range of tonal values expected in the finished piece, as shown in figure H. This approach is strongly recommended if values have been troublesome in the past.

E

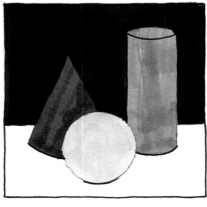

F

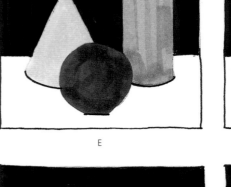

G

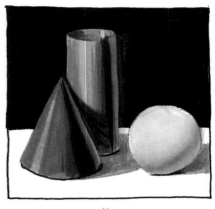

H

Don't Be Too Serious

Do not take a few simple sketches too seriously. Be serious about learning to see and use strong tonal contrasts, but do not waste a lot of valuable time and energy trying to get everything right the first time. If you have not had any luck so far with getting a strong image, you probably will not have any luck with your first attempt after having merely read about how to do it. Remember, if you are used to being cautious, using a bold approach will come slowly — and will shock you.

Rather than slave for hours over the underpainting, it is easier, faster and more productive to do several quickies. These provide a record of the false starts and eventual successes — and the visual proof that it is possible to produce a picture with strong, dramatic impact!

SQUINT A LOT!

If you want a magic trick that enables you to quickly see values, then squint! Squinting (at both your subject and your painting) effectively reduces value contrasts and eliminates distracting detail, leaving a view of just masses of light and dark shapes. Assuming your subject is well lit, you should see a fairly stark representation of your subject in highly contrasting values. If you do not see this same excitement in your painting when squinting, then you almost certainly have to adjust your values. Exaggerate, be bold and go for the jugular. In fact, go too far! You will eventually find some middle ground you feel comfortable with. But remember, the middle is located between two extremes. You have to experience the extreme to recognize the middle.

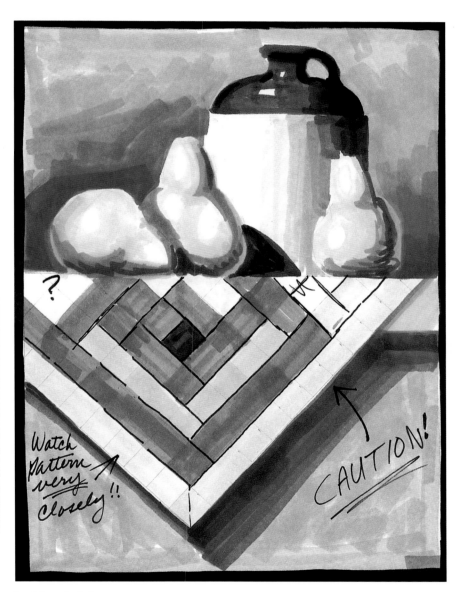

Problem Solving

As in the preceding four illustrations, this value study was done using Prismacolor gray markers. Although incomplete and far from perfect, it allowed me to solve several problems and forewarned me of others (such as the complexity of the quilt's pattern) long before I even blocked in the painting (the finished painting this value map produced is at the beginning of chapter four). The short amount of time I spent doing this sketch saved me hours of frustration and many headaches! I even went so far as to "ruin" my sketch by writing notes to myself.

PAINTING A GRISAILLE IN ACRYLIC

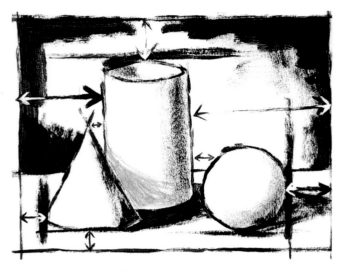

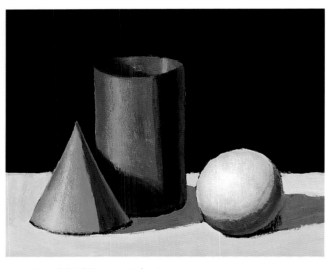

Step 1: Block in the Underpainting

Begin by boldly indicating the perimeters: the top of the tallest object, the left and right edges nearest the picture plane's left and right edges, and the lowest baseline(s) of the closest objects. Be sure the distances of the marks from the edges of the support are not all the same so there will be variety. Then loosely sketch the shapes included in the composition. Although not necessary at this time, suggestions of body and cast shadows could be added with paint diluted with only water or by scrubbing with a dry brush. Finally, visually check to see that negative spaces (the background) are varied and interesting at the objects' edges, both as they relate to the borders of the canvas and as they relate to each other (see arrows). To feel more secure, put the arrows in the picture. They will be covered in the next step anyway.

Step 2: Add White to Make Gray

Paint the background wall solid black. Then, adding various amounts of white to the black on the palette, mix a number of grays to suggest the values of the local colors of the objects. Finally, add a suggestion of body shadows if desired. (In the finished thumbnail sketch I did of this setup with markers, in D above, the colors seem to read as blue, red and yellow from left to right. However, I will not let the thumbnail govern what I need to do to create a stronger image. Do not be afraid to make changes for the good of the picture!)

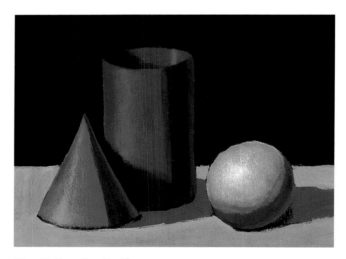

Step 3: Develop Further

Although I feel there is enough information available in step two to begin color additions in oils, the grisaille can be taken one step further to show even more subtle values, such as highlights and reflected lights, or richer shadows. Step two will probably be quite dry by this time, but adding these nuances is simple enough. Just darken any shadows with glazes (or washes) of water-thinned black paint. To suggest highlights, scumble or dry-brush white or light gray pigment where needed. The grisaille need not go further than this if there will be color overpainted with acrylics or oils, since the underpainting (and all of the time and labor spent doing it) will be covered by the new paint layers.

OVERPAINTING THE GRISAILLE

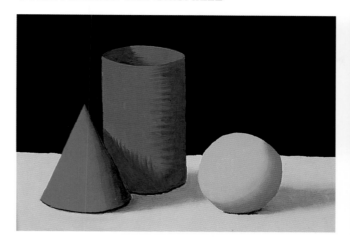

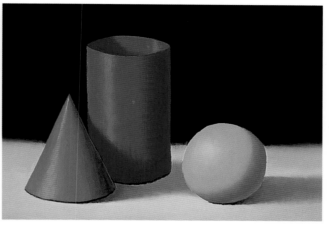

Step 1: Apply the First Color Layer

First, glaze the entire background wall with a mixture of Alizarin Crimson and Sap Green to produce a neutral but colorful black. Then, working from the back to the front of the composition (or top to bottom), loosely block in local color in the light areas. Do *not* paint light mixtures into shadow passages because light paint is next to impossible to cover with darker paint while it is still wet. Paint only to where the shadows begin, then darken and neutralize each mixture with its complement and paint the shadow masses.

Start the blend by running the tip of the brush through both values, creating "teeth." The degree of blending is governed by the size of the teeth. Wipe excess paint from the brush, and, with very light pressure, softly drag the brush through the teeth from light to dark, wiping the brush frequently (the cone, which had tiny teeth at the top that grew wider toward the bottom, and the sphere), until the desired effect is achieved. Sufficient quantities of paint are needed in both values to successfully manipulate the pigment for an effective blend. Thin mixtures will not do the trick!

The light and dark mixtures for each are Ultramarine Blue and Titanium White, darkened with more blue and neutralized with Burnt Umber; straight Cadmium Red Light, darkened with Alizarin Crimson and neutralized with Sap Green for the shadow; Cadmium Yellow Light and Yellow Ochre, darkened with more ochre and some umber and made neutral with crimson and blue (violet); and, for the tabletop, white, black and ochre, darkened with Raw Sienna and neutralized with violet.

Step 2: Add More Light

Using darkened versions of the local colors in light (with no complementary colors added), paint in any reflected lights that are seen or needed. For highlights, begin lightening each mixture as follows: For the cylinder, just add small amounts of white to the blue, painting progressively lighter values into the highlight area; for the cone, start lightening the red with small additions of Cadmium Orange (or even smaller quantities of Cadmium Yellow Light), then add white if more light is needed; and for the sphere, lighten with Cadmium Yellow Light, then white. For the tabletop, use white and ochre and work it into the original dingy white, gradating from light at the baselines of objects to a slightly darker value at the bottom of the canvas. This gradation suggests the movement back into space of the table's horizontal plane.

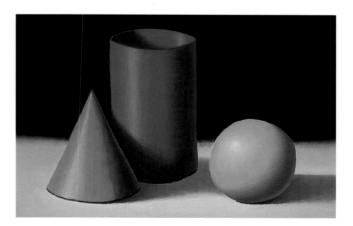

Step 3: Refine

When the painting is completely dry, enrich some of the shadow passages with glazes, if desired, which simultaneously makes their colors very luminous. Using a soft-haired brush, use crimson for the red glaze, adding a bit of green if needed. For the cylinder, use blue with a speck of umber, and the sphere gets a glaze of Raw Sienna, maybe a touch of umber, and a bit of violet in its shadow. The same mixtures may also be used to subdue any reflected lights that are too prominent (although I needed to lighten the red slightly). The cylinder's rim at the left rear was given a thin line of body color to separate the interior cast shadow from the background.

SEEING VALUE CONTRAST

Since the most obvious trait and most common definition of tonal value is its relative lightness and darkness, I will limit this investigation, for the moment, to that aspect only. In fact, I will go one step further and drop the word *relative* from that definition — at least temporarily. I will identify the obvious lights and darks. The relative aspect, which is so important to a thorough understanding of values, will be brought back into focus in short order.

Dark Against Light Against Dark Against…

In about 95 percent of my still lifes, my light source comes from the upper left. This constant lighting condition usually provides strong value contrasts throughout the setup. If I use natural light or a broad-beamed floodlight that evenly or uniformly illuminates the background wall, I either create a cast shadow on the wall by placing a board or other object in the light's path or, more often than not, "invent" a cast shadow or darker value on the left because, whether I actually see it or not, I need it there!

What that constancy of light amounts to in my finished work is this: Every one of my paintings can be read, from left to right, as dark (the background), against light (the left-hand or light side of my subject matter) against dark (the right-hand or shadow side of my subject matter) against light (the background, where the movement of light terminates).

When I want my background to be uniformly dark from left to right, I treat the shadowed sides of foreground objects in one of two ways: (1) Usually I paint a soft reflected light into the body shadow of the object to separate it from the

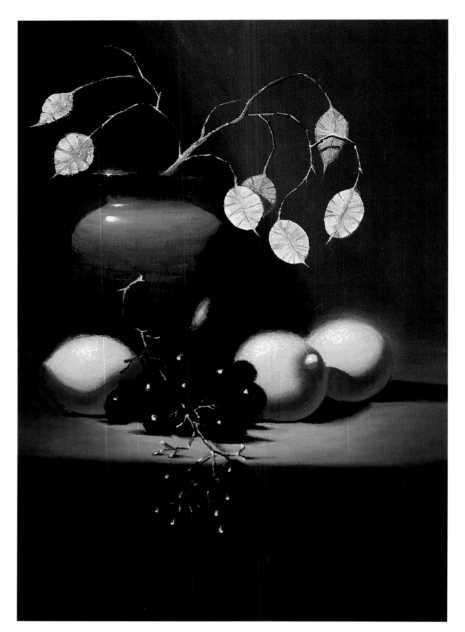

Lose Problem Areas in Shadows

When I painted *Grapes and Lemons,* I had not been painting long and was hard-pressed for the solutions to many problems (I am still hard-pressed for a lot of the answers — and probably will be for as long as I continue to paint). With this painting, however, I learned that you can hide ineptitude to some degree by losing problem areas in shadows, as I did with the right side of the vase. Since I was having a problem depicting its symmetrical form, I simply hid part of the vase by merging its body shadow into the shadowy background. This bit of cheating usually goes unnoticed by laypeople, and even by some experienced artists, until I draw attention to the fact. Of course, it is always better to do the job correctly, but when time or personal experience prevent it, a little trickery goes a long way.

Grapes and Lemons, Alex Kedzierski
16"x 12"(41cm x 31cm), Oil on canvas
Private collection (photo by Donald J. Nargi)

dark background. I almost always do this to separate the object's body shadow from its cast shadow on a tabletop or nearby object. (2) Sometimes I let a body shadow merge into the darkness behind the object. This is a particularly useful ploy when I am having trouble getting the symmetry of a shape correct (as in a vase). By losing the shadowed side of the object against the same-valued background, I solve the problem of accurately rendering the symmetrical form. Who says that cheating doesn't pay?

Of course, if I am having a lucky day, I underscore my success by adding light behind the shadow side of my vase or by introducing a reflected light into the shadow to separate it from a dark background. If I use the latter approach, the left-to-right reading would be as follows: dark (background) against light (object) against dark (body shadow) against light (reflected) against dark (background).

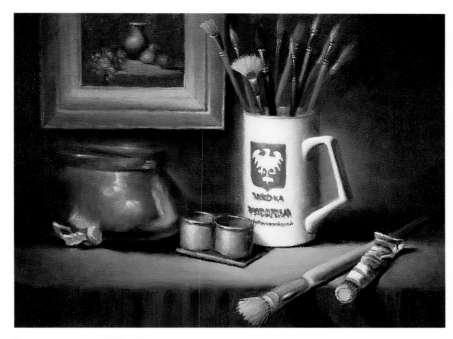

Create a Sense of Light's Movement

With *Studio Stuff,* the problem was not one of symmetry but of diverting attention from the left side of the painting. By losing the left side of the copper kettle, a sense of the light's movement from peripheral darkness to full illumination is established and acts like a path for the viewer to follow to the center of interest.

Studio Stuff, Alex Kedzierski, 12"x 16" (31cm x 41cm), Oil on canvas
Collection of Donna Hall (photo by Donald J. Nargi)

Keep Elements From Competing

Although the shadow side of the basket is not really lost, it was greatly played down in order to minimize any competition with the teapot in front. Also notice the dark against light relationships of the small red vase. Because of a fairly even illumination of the background throughout, I did not actually see the dark area behind the vase, but I needed it there to reinforce the vase's form and to push it forward into space.

Ikebana Basket With Bittersweet
Alex Kedzierski
30"x 22"(76 cm x 56 cm), Oil on canvas
Private collection
(photo by Donald J. Nargi)

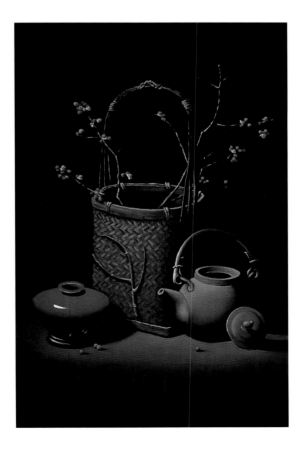

PAINT THE RELATIVE ASPECT OF TONAL VALUES

Values change within their environment and can look darker or lighter than they actually are, depending on the surrounding or adjacent tones. This relative quality is graphically illustrated in the following demonstration. Work through it carefully to see relativity in action.

Step 1: Establish the Composition
Using a gray pastel pencil, quickly block in the composition with a few gestural lines followed by some loose, sketchy marks to suggest shapes. The goal is to just make sure all of the elements fit attractively and comfortably on the support (9"x 12" [23cm x 31cm] in this instance).

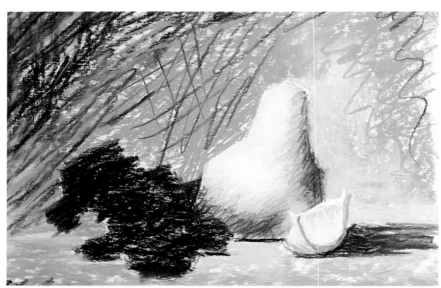

Step 2: Suggest the Tonal Range of the Picture
With hard pastels (Nupastels), quickly suggest the value range of the work, broadly covering the paper with the sides of the pastel sticks and with very loose scribbles, hatch and crosshatch marks.

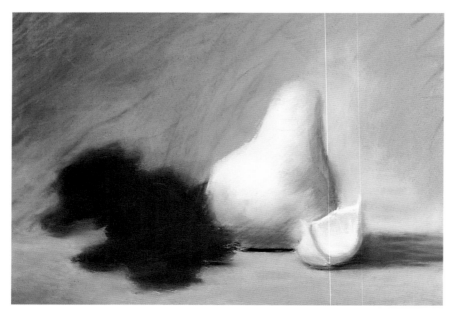

Step 3: Rub and Brush
Working from light to dark, rub the pastel into the paper with your fingers or a blending stump. Do not be shy at this stage — really rub the dust into the surface to cover the paper completely. (It is best to use light applications of pastel and blend to get coverage rather than to use heavier applications, which would prematurely fill the tooth of your paper and prevent further layers of pigment from being added.) Then brush the surface vigorously with a hog's hair bristle brush to remove excess pastel dust. A ghost image will be left to work on in further stages.

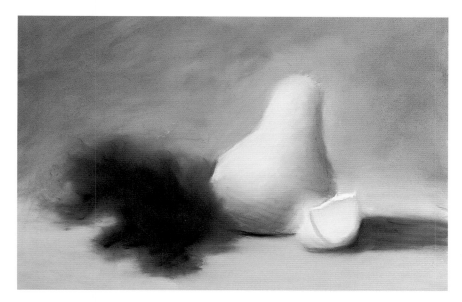

Step 4: Add Color
Because preserving the paper's tooth is such a big factor, do not try to develop the underpainting with highlights, accents or detail. Instead, start working with light applications of color immediately, still using the hard pastels and the same approaches to applying the pigment as in steps two and three, including rubbing into the support. Omit the brushing off of pastel dust at this stage, however!

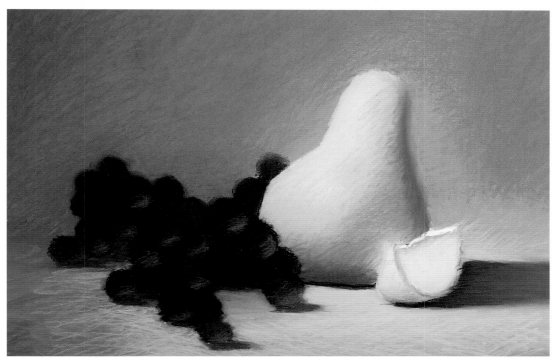

Step 5: Refine With Soft Pastels
Working with softer pastels (I'm using Rembrandts here), refine the values, shapes and colors. Use a light touch and fairly loose strokes to get coverage from this point on. Use little or no blending in order to keep the color fresh and vibrant. (The shadow side of the pear's edge and the grapes' edges against the background were softened with my finger to push them back into space. All of the other loosely applied strokes were left untouched.)

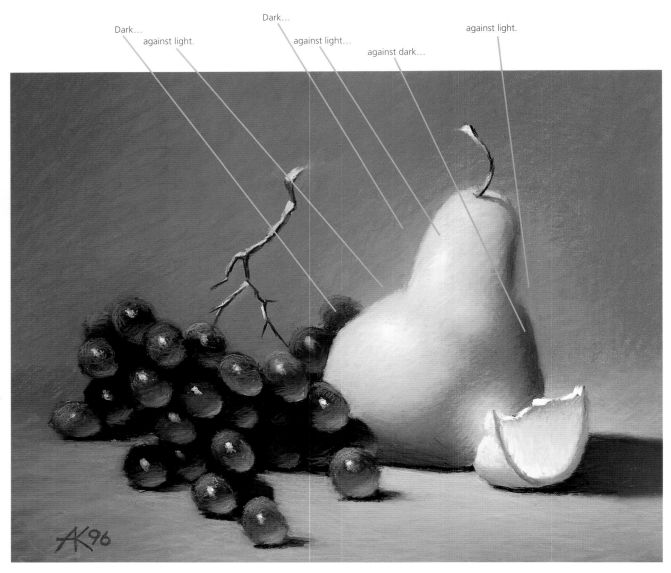

Dark...

against light.

Dark...

against light...

against dark...

against light.

Just Some Fruit, Alex Kedzierski
9"x 12"(23cm x 31cm)
Pastel on Ersta Starcke extrafine-grit
sanded paper
Collection of Robert and Gladys Demmien
(photo by Donald J. Nargi)

Step 6: Add Finishing Touches

Here, tighter hatching and crosshatching must be used to smooth out the image, but no other blending should be used. Crosshatch warm and cool greens onto the pear to produce a shimmering effect of light. Stroke darker greens over dark red-violets and red-oranges to produce colorful and luminous shadows in the pear. The same use of complements in the other shadow passages works similarly, spreading color and temperature contrasts throughout the picture. Finally, apply strong highlights with the softest pastels available (Senneliers are used here). Using really heavy pressure on the pastel sticks at this point will result in thick impasto highlights that reflect light in a very exciting manner. Also notice that the background's fairly uniform value can be interpreted as either dark or light, depending on adjacent values (see arrows).

THE DIFFICULTY OF HAVING TOO MUCH TO DO

Perhaps the most difficult problem to deal with when working on a piece of artwork is simultaneously juggling a seemingly endless number of interrelated elements: composition, or the design, of the picture; linear and atmospheric perspective (whew!); accurate depiction of shapes and forms; variety of shapes and sizes; receding and advancing spatial relationships; color (which includes the color or hue itself, its temperature or warm/cool/neutral quality, its chroma or relative brightness or dullness and its tonal values); plus the many facets that values themselves have in addition to their light and dark relationships.

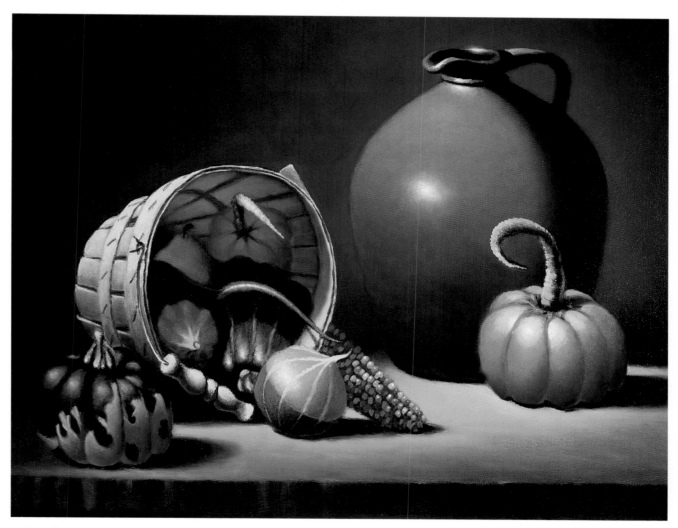

Paint What Is Needed, Not What Is Seen

This painting was started with an acrylic grisaille then finished by overpainting in oils. The background was not particularly well lit, and I could not actually see the shadowed side of the pitcher, including its handle, against that dark tone. However, since I wanted to show the handle, I fudged on the values in that area. In fact, I painted what I needed for the good of the picture no matter what I actually saw!

Bounty, Alex Kedzierski
16"x 20"(41cm x 51cm), Oil on canvas
Collection of the artist (photo by Donald J. Nargi)

Added to all of the above, balance must also be considered. For a picture to be well balanced, it cannot have an even distribution of light and dark, warm and cool, bright and dull, hard and soft, thick and thin, far and near — well, you get the picture. Why? Because that kind of symmetrical formality is monotonous — even Boring with a capital B.

That is an awful lot of juggling to do. And bear in mind, all of those difficulties are interdependent and must be considered all at the same time, not as disparate elements that might eventually come together at the end to make up a finished piece of art.

But basically, that is what creating successful paintings is all about — that is our job. We must orchestrate all of these things and produce a cohesive, uniform image, containing multiple levels and problems that must appear to exist in the same place at the same time.

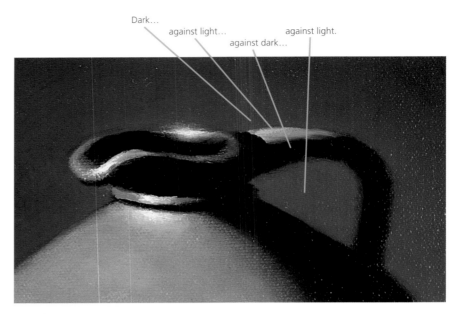

Dark... against light... against dark... against light.

Detail
Although the background value behind the handle is fairly uniform, it can be interpreted as either dark or light, depending on an adjacent tone, as shown by the arrows.

Detail
If a piece of paper with a four- or five-inch opening in it were held over any part of the painting, the dark against light relationships would still be easily seen. Of course, those relationships could also be obscured at will if necessary, as I did in this instance with the squash. I did not want too much activity in the lower left corner or too close to any of the canvas's boundaries, so I lost the left side of the squash with soft edges and very close values. The viewer will ignore these uneventful areas and look to the more exciting passages of high tonal contrast and bright color.

Now look at the full painting of *Bounty* once again but with the express purpose of picking out these dark/light areas. In fact, look at any or all of the pictures in this or any other book to find these areas. Once you get used to seeing the dark to light relationships in other pictures, it will be easy to recognize them in your own work. If they are missing in your work, then adjust values until these relationships become evident. Keep squinting!

CREATE A STRONG SENSE OF LIGHT AND DARK

In this start-to-finish painting demonstration, take particular notice of the fact that early in the development of this piece there is a strong sense of light and dark. Although light (and color) will be the most striking element in the finished picture, the use of rich darks in the early stages of development is what gives strength to the overall design of the piece, as well as a convincing illusion of gravity-bound volume and weight.

Step 1: Block in the Placement of the Objects

Starting with Burnt Umber thinned with turpentine, make a few bold vertical marks to show how far to the left and right the edges of the leftmost and rightmost objects will be placed. Then add horizontal strokes to indicate how high the tallest object will be and where the baselines of each object will be, that is, the points where an object actually touches down and rests upon a table or other surface. Then quickly suggest the objects themselves with a few lines. The objective at this stage of development is to make sure all of the elements fit comfortably and attractively within the confines of the support being used. If this first step is not correct, then no matter how well you continue to paint, or for how long — particularly if you are unwilling or unable to make future adjustments — you will still end up with a well-painted but bad picture!

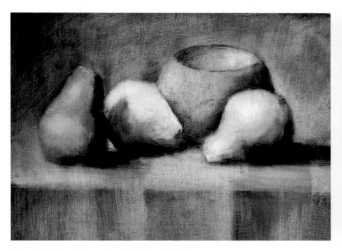

Step 2: Develop the Underpainting

Still using the turps-thinned Burnt Umber, scrub in darks and middle values using the earlier drawing as a guide. Then wipe away light areas with a rag. Step back about ten or fifteen feet, and squint at the painting to see if it carries well at that distance. If the lights and darks are nicely balanced and attractively placed, and if you are satisfied with what you see, go to the next stage of development. Otherwise, continue working until you are happy with the results to this point.

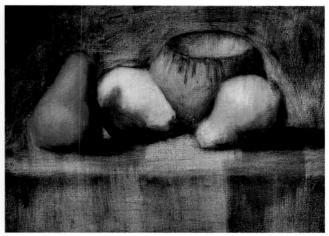

Step 3: Glaze Local Colors

When the underpainting is thoroughly dry (overnight should do it), switch from turps to an oil painting medium (I am using Winsor & Newton's Liquin in this demonstration). The main concern should be to get some paint down that can be worked into comfortably during the next stage of painting. (Warning: Due to the quick drying properties of Liquin, I recommend waiting until this stage is dry before going on because the Liquin sets up very quickly and can cause brush drag and other problems for the painter who is unfamiliar with this medium. Once again, overnight should do the trick.)

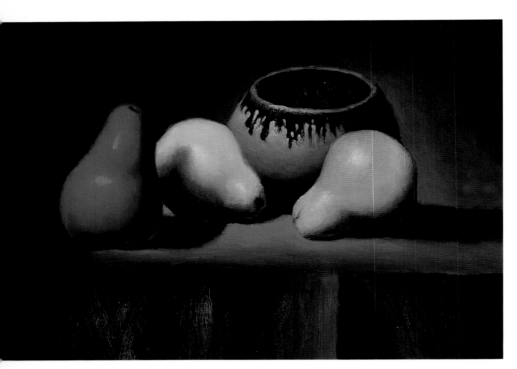

**Step 4: Begin Layering
With Opaque Paint**
Start adding more opaque mixtures with the goal of getting better coverage of the support, correcting shapes and values, and coming closer to the finished colors. Scrub in a suggestion of the drapery folds overhanging the table. (I am not happy with the background and table color right now but will hold off making adjustments until I see how it relates to everything else later. I am also having trouble getting the red pear to look exciting. I will have to think about that for a while.)

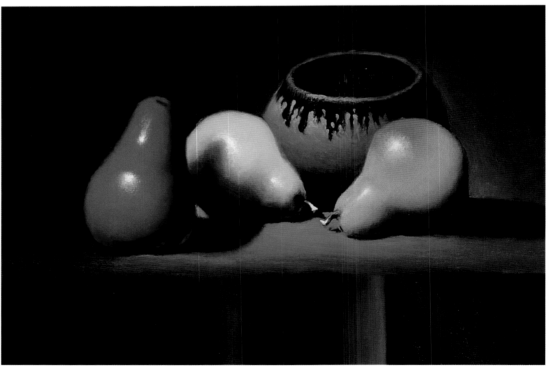

Step 5: Modify as Needed
Modify the pears with additions of lighter, brighter color, then darken the shadows with thin glazes of complementary color. Begin adding light to the table's surface at this time, and start repainting the folds with more care as well. Do not forget to step back occasionally to make sure the value contrasts are holding up and remain strong. This is particularly important with the relatively dark red pear's relationship to the dark green background. Also, carefully check the pears' reflected lights, which separate their shadow sides from their cast shadows. (I am still not happy with the red pear but hope to resolve that problem in the final stage. I am also having trouble with the red-orange blush on the far right pear.)

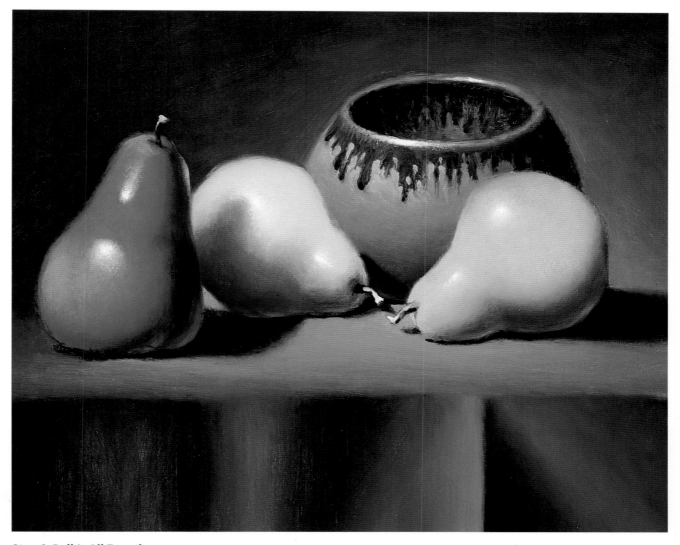

Step 6: Pull It All Together

Final adjustments of color and value will pull the piece together. Add a glaze of Raw Sienna to the top and bottom left of the red pear in order to add some variety to its unrelieved redness. Then add a thin glaze of Alizarin Crimson to the remaining red areas to darken and simultaneously add brilliance to the rest of the pear. Add a subtle yellow reflection (from the center pear) to the top right-hand shadow of the red pear. This adds visual excitement to the area and separates the pear's shadow from the dark background value. Subdue the blush on the right-hand pear by scumbling the yellow pear color over the red-orange. Finally, add a highlight to the bowl's rim and restate the highlights on all of the pears if necessary.

One Out of Three, Alex Kedzierski
11"x 14"(28cm x 36cm)
Oil on acrylic-gessoed Masonite
Collection of the artist
(photo by Donald J. Nargi)

BUILD A STRONG FOUNDATION

In this next demonstration, notice how adjustments and refinements are made in light to dark relationships, particularly in regards to the degree of contrast, as well as in color, edges and so on. But remember that the strongest work can be done only if there is a strong scaffolding on which to build. The structure of a drawing or painting must be there from the beginning. The necessary support cannot be added to a weak finished picture.

Step 1: Block In

Using turps-thinned Burnt Umber, block in the composition with a few lines to suggest the placement of objects on the support (as in the preceding demonstration), then scrub in some darks and middle tones in the approximate value range to be used. Finally, rub out some of the lighter tones with a rag, then step back about ten to fifteen feet and squint at what is there so far. If it reads well and carries strongly from that distance, go to the next stage of development. If not, continue to adjust value, placement or shapes until satisfied.

Step 2: Establish Local Colors

Suggest local colors with more opaque paint thinned slightly with turpentine, being careful not to lose the value map by confusing color contrast with tonal contrast. The main objective is to cover the entire surface of the support with a loose application of paint that will be receptive to future additions. (I refer to each stage of a painting session as laying down quality paint; that is, each new paint layer should have a quality or condition about it that will make additional layers as trouble-free as possible. It has nothing to do with the price of paint.)

Step 3: Refine

Using even more paint, loosened with an oil painting medium to ease the flow, rework the entire surface of the painting, making any necessary adjustments in values, color, shapes and so on. (I changed my background color to a murky yellow-green, but I also made sure the values still work with all other adjustments being made.) Develop the melon's flesh with mixtures of various orange values, and suggest the coarse outer rind with a thick stipple of light, dull yellow-green. If needed, reshape the dark mass representing the grapes and suggest the roughly sawed side end of the shelf with a few vertical strokes.

Step 4: Build Excitement

Lighten the background where needed, particularly behind the melon's shadowed side. Keep the values behind the grapes very close; this lack of tonal contrast aids in suggesting the illusion of recession into space, pushing those grapes back. Further develop the melon's rind with lighter values and thicker paint, and lighten the orange flesh color even more. Accent the flesh shadow with glazes of Burnt Sienna and a small amount of Ultramarine Blue. Begin lightening the horizontal plane of the shelf, but only to get some quality paint down, not with any thoughts of tonal or color accuracy. Finally, glaze the grape mass with a mixture of Ivory Black and Alizarin Crimson, then add small amounts of Cadmium Red Light to the glazing mixture (a little at a time) and start creating grapes by painting transmitted lights into the wet glaze on the undersides of the grapes you "carve" out of the mass.

Try to avoid the gumdrop or cannon-ball look by leaving some unpainted areas to suggest missing grapes. (Sometimes, a suggestion of stems can be added to these dark holes in the bunch.) Also, don't let any of the grapes just touch each other at the edges, which would create undesirable tangents. They should either overlap or be completely separated. With a mixture of black, white and blue (keep this fairly dark to start with; it can always be lightened), paint the haze on the light sides of several, but not all, of the grapes. Then add highlights of pure white, manipulating them with the pointed end of the brush handle to diffuse them slightly.

Step 5: Add Even More Punch

Glaze the dark sides of the grapes (including the transmitted lights) with Alizarin Crimson, then add small amounts of Cadmium Red Light into the wet glaze to any grapes to be emphasized or beefed up a little more, lightening (and somewhat dulling) the mixtures with Yellow Ochre. A suggestion of some stems can also be added against the background using any rich, dark color. The shadowed side of the melon's outer skin can be darkened with a glaze of Raw Umber, Sap Green and Alizarin Crimson. (The light side was a mixture of Raw Umber, Yellow Ochre and Titanium White.) The lightest lights should be painted thickly. The melon's flesh can be further lightened with mixtures of Cadmium Orange, Naples Yellow and white. Add a speck of Sap Green into the lightest orange mixture, then coax this color into the wet paint along the edges where the melon's flesh meets the rind. Paint the shelf with varying quantities of Burnt Umber, Burnt Sienna, Venetian Red and white. Darken the sides and upper corners of the background with the same glazing mixture as used for the melon rind in shadow (with a bit more crimson added). Then lighten the area to the right rear of the cantaloupe to visually separate it from the background and to push it forward.

Step 6: Make Final Adjustments and Refinements

Now is the time to make the last adjustments and refinements in an effort to pull it all together. Feeling that my grapes were too uniform in color and intensity, I repainted a few of them, starting with a mixture of black and Cadmium Red Light. I added more red to the mixture as I worked on the transmitted lights, slowly building the intensity, and finally, a speck of Naples Yellow for the lightest crescent edges. With a dirty brush, I added a single grape on the right, which I feel improves the balance of the composition. (It is never too late to improve a picture.) A velatura (which means veiled; think of it as a semiopaque glaze or a semitransparent scumble) was added to the area to the right of

the melon to further lighten that area and to add air behind the cantaloupe. For this process, I used Shiva's Permasol White (a transparent white), using progressively less pigment and more medium as I worked away from the melon and toward the shadowy boundaries of my support. (Titanium White can also be used — I have used it myself — just be careful not to overdo it.) I then restated the grapes' stem with a dark glaze, softening it with my finger to push it back into space. Next, I intensified the green where rind meets flesh, using Grumbacher's Thalo Yellow Green. An even lighter version of the orange color was then scumbled over areas of the melon's flesh, both to subdue the raw intensity of the color and to suggest the wetness of the fruit.

Cantaloupe With Red Grapes
Alex Kedzierski, 11"x 13³⁄₈"(28cm x 34cm)
Oil on acrylic-gessoed cold-pressed watercolor paper
Collection of Sharon Ohnmeiss
(photo by Donald J. Nargi)

WHAT IS THE POINT OF ALL THIS?

If you had difficulty with any of the demonstrations, seek solutions with a thorough and conscientious study of those problems — one at a time. Haunt your local library, browse a good bookstore, study the paintings of artists you admire, talk to artist friends and colleagues and ask questions. But do not bother any of your non-artist friends or family. It is true that you can count on them for glowing critiques of your efforts, but they cannot be counted on for answers. They may not even begin to comprehend the questions, but that's not their fault. It's just that someone who does not practice a given discipline cannot reasonably be expected to advise someone who does.

Remember that whether you are looking into composition or color theory, perspective or value (as you are here), take it one step at a time. Learn one rule thoroughly enough to use it comfortably and effectively, then go on to face (and vanquish) the next challenge.

Practice, Practice, Practice!

As you work, do not try to absorb and retain complex information from a "real" painting. Do not practice on the paper or canvas you are hoping will find its way onto the walls of the Louvre. Practice on scraps. Do sketches or studies only — lots of them! You will learn quickly if you learn slowly. One successful step at a time will transport you to your goal. Conversely, haste makes waste! By having to restudy and relearn a technique, or rework passages of a drawing or painting that are in error because of your hurry to finish, you waste time that would have been better spent getting it right initially.

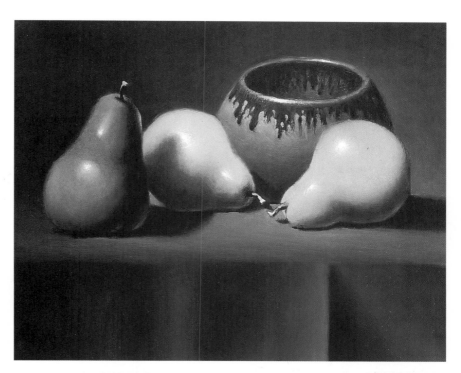

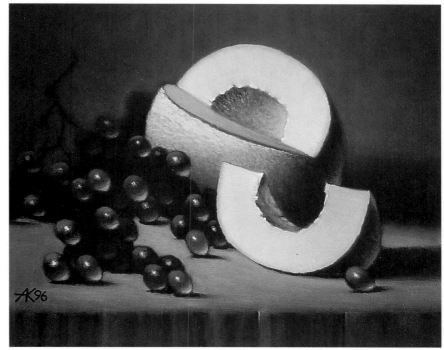

Proof of the Pudding

In these black-and-white reproductions of *One Out of Three* and *Cantaloupe With Red Grapes*, the values alone read very well. Beautiful as it is, color is just so much icing on the cake. It is certainly of secondary importance (or, actually, of absolutely no importance!) in the depiction of form and dimension. Color merely serves to decorate tonal values, which are vitally important to the success of a realistic image.

Work Out Specific Problems

When I teach class, I often carry a pad of tear-off canvas sheets on which I can do quickie demonstrations for students who might be having trouble. A few minutes invested in these practice sketches (some of which I have shown here) are worth the effort, considering that these quickies help solve problems with shape or mass, value, color, edge handling and more. I even encourage my students to practice on their own just after my demo, either on a piece of scrap canvas or directly on some part of the easel, before tackling the troublesome passages of their paintings.

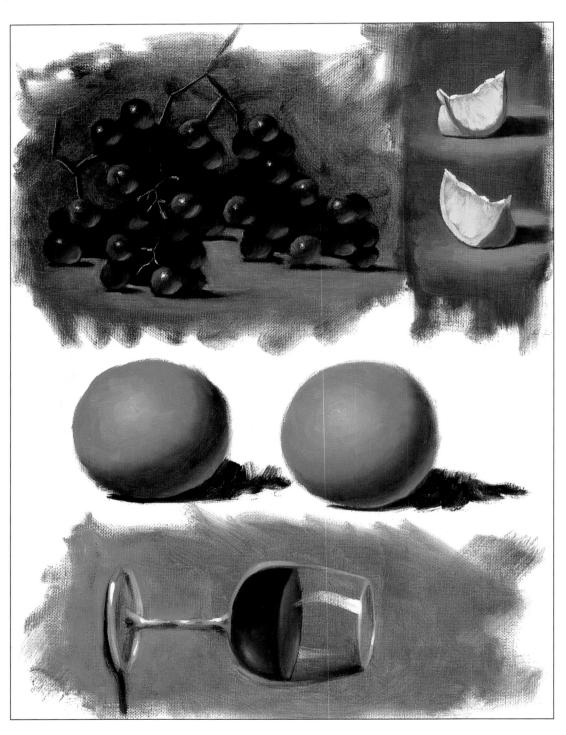

Practice Small
This tear-off canvas sheet illustrates a typical quickie demonstration I occasionally do for my students (rather than solving a problem directly on one of their paintings). I carry a pad of sheets with me as I walk among their easels so I can quickly demonstrate a particular process or specific point. In five to fifteen minutes (the bunch of grapes may have taken up to twenty), they get the gist of how to approach a similar painting problem in their own work.

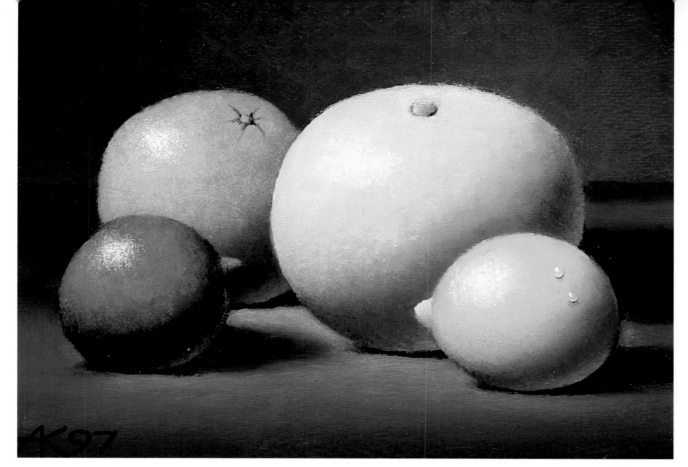

Citrus Fruit, Alex Kedzierski
6¼" x 7¾" (16cm x 20cm)
Oil on acrylic-gessoed cold-pressed watercolor paper
Collection of the artist (photo by Donald J. Nargi)

REMEMBER:

- Value studies and underpaintings give an immediate sense of value distribution and balance — something that is not always easy to see and keep under control in color.
- Underpaintings executed in a single color are monochromatic; done in black and white, they are known as grisailles or achromatic.
- The motor skills involved in the physical act of doing something are what finally impress themselves upon your mind.
- Tonal values provide artists with the enormous and unlimited potential to make their work more exciting.
- Practice a lot and play with values!
- Squinting reduces value contrast and eliminates distracting detail, leaving a view of just light and dark masses.

- Be bold and go for the jugular — go too far! Find the middle ground between the extremes.
- Look for light against dark, dark against light.
- Values change within their environment and can look darker or lighter than they actually are.
- Consider balance.
- Someone who does not actually make art cannot reasonably be expected to advise someone who does.
- You will learn quickly if you learn slowly. Remember, you'll be learning for the rest of your life.
- The structure of a drawing or painting must be there from the beginning.
- Support cannot be added after the fact to an already finished, weak picture.

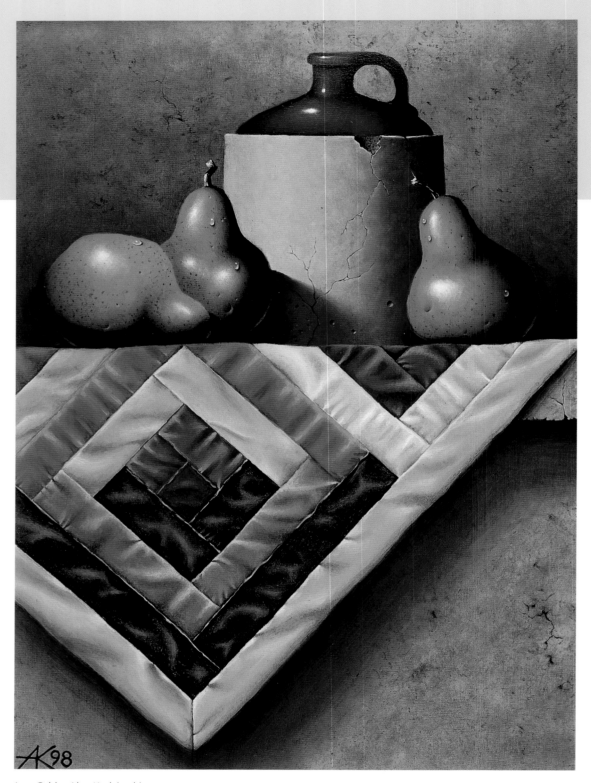

AK98

Log Cabin, Alex Kedzierski
15"x 11"(38cm x 28cm)
Oil on acrylic-gessoed hot-pressed watercolor paper
Collection of the artist (photo by Donald J. Nargi)

The Value of Color

Color is a vast and complex subject, and I am very opinionated about it and its use. Nothing that I have to say, however, is carved in stone. As I continue to learn and grow as an artist, my views and approaches change. So will yours in all probability. Feel free to discard any concepts that, for the time being, simply do not work for you. Review them later, however, when a little more personal experience may help you to understand them more thoroughly.

In this chapter, I will introduce the interrelationships of color to value, an important area of study because the effectiveness and believability of any realistic image depends entirely on the successful combination of color and value. I will also develop two grisailles from a previous chapter in full color. Value is a pretty vast and complex subject in its own right. Understanding how it works in conjunction with color is just another of those necessary evils. But take it all slowly, one step at a time, and you have more than a fighting chance at success. And remember that though most of what you see in this chapter was done in oils, the same rules apply to all mediums.

This painting takes its title from the pattern used in the quilt. The log cabin is seen from a bird's-eye view, and the central red square is said to represent the hearth while the progressively longer strips of material represent the logs. With the exception of the blue strips, the cloth pieces are very close in both value and color, so great care was needed when juxtaposing the light and shadow tones to convincingly show where the cloth strips were joined.

THE CHARACTERISTICS OF COLOR

Color has four properties: hue, temperature, chroma and value. It is necessary to know about these before discussing triadic color theory (so named because the color wheel is based on triads, or threes: three primaries, three secondaries, and three warm and three cool intermediary colors).

Hue

The name of the color itself, as in a red apple, a yellow banana or a green leaf, is referred to as hue. It is also often referred to as the body, or local, color of an object. The words *hue* and *color* are synonymous and interchangeable. As artists, we must concern ourselves with only six hues: red, orange, yellow, green, blue and violet. Period! For now, ignore all other designations, such as brown, pink, chartreuse and sky blue.

Temperature

There are two aspects of color temperature: warm and cool. Red, orange and yellow are said to be warm colors, while green, blue and violet are considered cool colors. With the exception of orange (which is always warm as it can only lean toward yellow or red), all the other colors have warm and cool variants. Red can tip toward orange (as Cadmium Red Light does), making it a warm red, or toward violet (as in the case of Alizarin Crimson), turning it cool. Yellow can have an orange cast, which keeps it warm, or it can move toward green, which cools it. Likewise, blue can have a violetish, warm hue (as with Ultramarine Blue) or a greenish, cool quality (as with Phthalo Blue).

Although violet and green are generally considered cool colors (because of the blue in their com-

Farm Shed
Dorothy Angeli
9"x13½"
(23cm x 34cm)
Watercolor
Collection of the artist (photo by Donald J. Nargi)

Color and Tone Can Create Atmosphere
The stark severity of the tonal contrast is what makes this painting so strong. But color plays an important role in the overall feeling of atmosphere as well. Dorothy Angeli's adroit use of color temperature lets observers feel the heat of the sun pouring in and makes them want to move into the cool shadows on the left, depicted with washes of blue and violet. The sunlight strikes the floor and bounces back into the shadows on the right, lightening and warming them simultaneously. At the same time, the artist's use of subdued color throughout strongly suggests the illusion of an almost palpable dustiness inside the shed.

positions), they can at times appear quite warm (because of the red and yellow in their makeup), depending on surrounding color temperatures. In a winter landscape composed of predominantly cold blues and grays, touches of violet and green (in tree trunks and limbs, or on rocks, for example) look very warm indeed. Conversely, an autumn landscape made up of warm reds and

oranges would make accents of violet and green look quite cool.

Chroma

Chroma is a color's relative brightness or dullness. Fire trucks are often painted a bright red hue, but a brick is a much duller red. An orange (the fruit) has a bright hue, or high chroma or intensity, while a rusted bucket has a duller hue, or a low chroma or intensity.

Value

The fourth characteristic of color, and perhaps the most important, is value, or color's relative lightness or darkness. An apple might be a middle-value red, but a light pink blouse is a high-value red, while a glass of burgundy wine would be a very low-value, or dark, red. Of course, because of lighting conditions, the values will change drastically on a single object. A copper kettle's local color might be middle-value orange, but any highlights would be very high values (and also very bright, possessing high chroma), and any shadows would have to be lower-valued, or darker orange, hues (and would have a lowered or duller chroma as well).

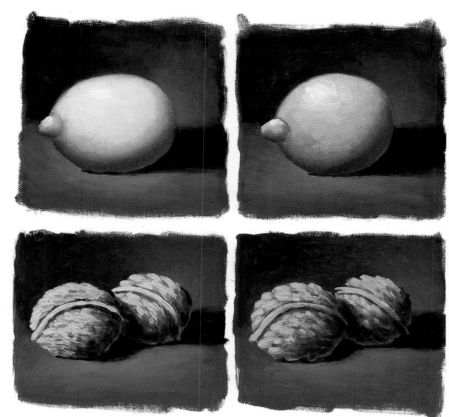

Keeping Chroma Correct

Although both lemons above share the same value contrasts and the same amount of light, and both are painted yellow (Cadmium Yellow Light on the left and Yellow Ochre on the right), only the high-chroma (or brightly colored) lemon on the left is convincing. The walnuts were painted in a similar manner using the same two yellows, but in their case, the low-chroma (or duller-colored) pair on the above right is the more believable of the two. In the black-and-white reproductions of these illustrations to the left, it is easy to see how the values can be accurate even when the color intensity is way off.

THE COLOR WHEEL

The standard triadic color wheel is composed of twelve colors divided into four groups: primary colors, secondary colors, intermediary colors and tertiary colors. A quick glance at any color wheel shows that the lightest color, yellow, grows progressively darker on both the warm and cool sides of the wheel as it moves down toward the dark violet at the bottom of the wheel.

I use a form of shorthand when naming colors on the color wheel. My shorthand has a method: Uppercase letters indicate the primary colors, lowercase letters the secondaries. As we progress in our study of color theory, we will use this shorthand to effectively indicate combinations of primary and secondary colors.

COMPLEMENTARY COLORS

Colors that are directly opposite each other on the color wheel are known as complementary colors. They share the following duality of nature: When pure colors are placed side by side, they energize each other and appear more vivid and exciting; when mixed, however, complements neutralize each other and become more and more grayed as more and more of a complement is added.

The Color Wheel

The triadic color wheel is composed of twelve colors: three primary (yellow [Y], blue [B], red [R]) three secondary (green [g], violet [v], orange [o]) and six intermediary (yellow-green [Yg], blue-green [Bg], blue-violet [Bv], red-violet [Rv], red-orange [Ro] and yellow-orange [Yo]). Colors directly opposite each other on the color wheel are known as complementary colors.

In the two color charts below, columns one and five show the twelve spectrum colors from red to red-violet. Columns two and six show the complementary colors beside each of the first dozen colors. In columns three and four, small amounts of complements have been added to each color (a bit of green added to the red and a bit of red added to the green, a touch of blue-green added to red-orange and some red-orange mixed with blue-green, and so on). In columns seven and eight, greater amounts of complements have been added to each of the base colors.

The Primaries

Yellow, blue and red are called primary colors because they must be on the palette to begin with. They are not mixes.

The Secondaries

Orange, green and violet are known as secondary colors because they are made by mixing two primaries: red and yellow to make orange, yellow and blue to produce green, and blue with red to get violet. I bet you remember that from your earliest school days. (For me, it was more like school *daze*.)

The Intermediaries

Between each primary and secondary color is an intermediary color. These six colors are more commonly called tertiary hues. But in fact, they are not! Think of them instead as primaries that lean toward a neighboring hue. Red-orange, for example, which you might formulate by mixing red plus red plus yellow, is simply a warm red that leans toward orange. Likewise, blue-violet, a mixture of blue plus blue plus red, is nothing more than a warm blue with a violet tendency. The names alone (*red*-orange and *blue*-violet) are descriptive enough to dispel any doubts.

The Tertiaries

A tertiary color is a mixture that contains all three primary colors in any proportion. When any color on the wheel is mixed with the color directly opposite on the wheel, the two colors become neutralized, grayed, dulled. For example, if red is added to green (a mixture of blue and yellow), or vice versa, all three primaries are combined to make a tertiary hue. It does not matter how minute the quantity of red, it will be enough to dull the green slightly and more than enough to produce a tertiary. In short, any (and all) color that is neutralized with its opposite, or complementary, color can be called a tertiary color.

The Achromatic Tones

Though not shown on the color wheel, the achromatic, or colorless, pigments are black, white and, by extension, all of the countless grays. When used correctly, black, white and gray are not only effective darkening, lightening and neutralizing agents, but they are also essential tools to have on the palette in order to exercise greater control over chromaticity of raw color. Since black, white and gray are called tones rather than colors, any colors that are neutralized with these tones are also called tones because they are toned down by the process.

Black

I do not subscribe to the assertion that black should never be used because it muddies or dirties a color. In fact, I have seen more than enough muddy color in pictures where black was conspicuously absent from the palette.

I also disagree with the blanket statement that black should not be used because the Impressionists dropped it from their palettes; it is not entirely accurate. Although some of them did, and some dropped all earth colors from their palettes as well. But Degas, Manet and Renoir, to name only three who were at or near the top of the Impressionist heap, all used black, often lavishly, although with a knowledge and awareness of the potential problems of using it. In fact, Renoir is reported to have called black "the Queen of all color!"

The silliest excuse for not using black is that it is not a color. Humph! That is true, of course, but based on that notion, should we also ban the use of white in our work? As far as I am concerned, if using black was good enough for the likes of Goya, Rembrandt, Velazquez and so many other of the Old Masters, it is certainly good enough for me.

White

Although not a color, white is so important, at least in wet opaque media, that it is sold, purchased and used in larger quantities than any other pigment. Like its complementary, black, white can be, and often is, directly responsible for all kinds of problems, including muddy color.

One of the biggest problems with white is the use of too much of it too soon. Although it is an important lightener of color, it does have drawbacks. For starters, too much white makes color look chalky or bleached out. Being a cool tone, it cools off the warm side of the color wheel. And, being an equal partner in the composition of gray, white actually grays down, or dulls, color that it is added to. Of course, the more white you add, the more evident the cooling and graying of color will become — and the more chalky. Later there will be a discussion of how to get around some of these difficulties.

USING BLACK, WHITE AND TONES
TO PAINT WATER DROPS

These two methods for painting water drops utilize only black, white and colored tones. To make the job a little easier, use a light touch and wipe the paint off the brush frequently during all blending stages to avoid altering the values too much, and to avoid making mud.

METHOD 1

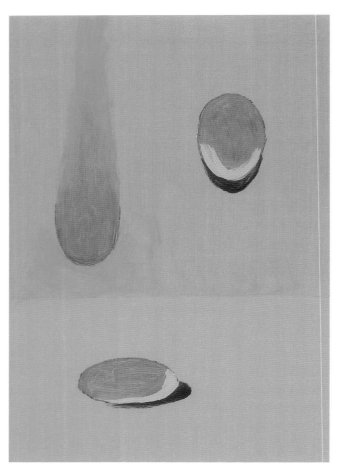 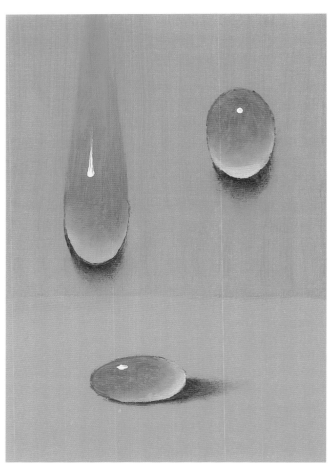

Step 1: Block in the Tones
Using black, create a color two or three tones darker than the body color, and paint the shape of the drip or drop. The drip could start at approximately the same value as the body color and grow progressively darker as it runs downward, as shown in the drip at the left.

Step 2: Place Lights and Shadows
Using white, create a color two or three tones lighter than the body color, and paint a crescent-shaped transmitted light at the bottom, or veering to the right of the respective drops. Then, with a much darker tone (perhaps add some complementary color to the mixture), paint the cast shadow under or to the right of the respective drops, as shown in the drip to the right and in the drop at bottom.

Step 3: Blend
Gently soften the upper edge of the transmitted light up into the drop, and then gently soften the lower edge of the cast shadow down into the body color. Finally, add a tiny dot of pure white near the top for the highlight. Although not necessary, the highlight can be dragged upward on the drip to elongate it and further suggest the dribbling movement of the liquid, as shown in the drip at left.

Step 4: Add Punch to the Lights
If the transmitted light in step three is overblended and its value too dark, add a little core of additional light in a crescent shape at the bottom or to the right of the drop adjacent to the cast shadow. Then, softly blend the hard edge into the drop once again, as shown in the drops at right and bottom. This transmitted light must be strong enough to support the brilliance of the highlight.

METHOD 2

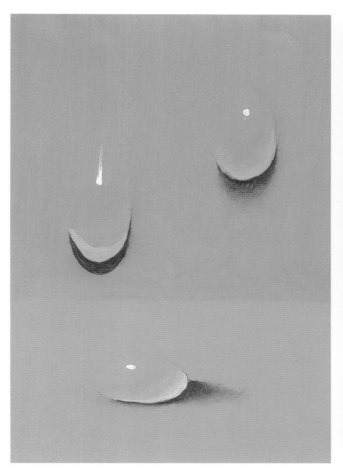

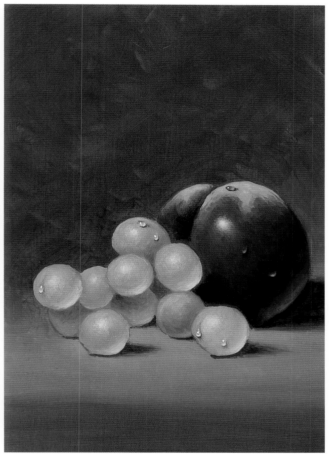

Step 1: Place Lights and Shadows

As shown in the drip to the left, begin by painting the transmitted light and cast shadow as outlined in step two of method one.

Step 2: Blend and Highlight

Continue by blending these values and adding highlights to the drops as described in step three of the previous method, as shown in the right-hand drip.

Step 3: Make Final Adjustments

If necessary, restate the transmitted light for added punch, as shown in the drop at bottom.

Which Method to Use?

Both approaches to painting water drops are valid and inter-changeable, or either method could be used exclusively. I use both methods, but I work with the following guideline: If the drop is on an object for which the body color is pure, I use the second meth-od; if the drop is on an area of gray bloom or haze (as on plums or grapes, or on the grayed fuzz of a peach or on frosty cold glasses), I use the first method, starting with the object's body color (in a darkened version if necessary), which knocks back the grayed or lightened areas where the drops appear.

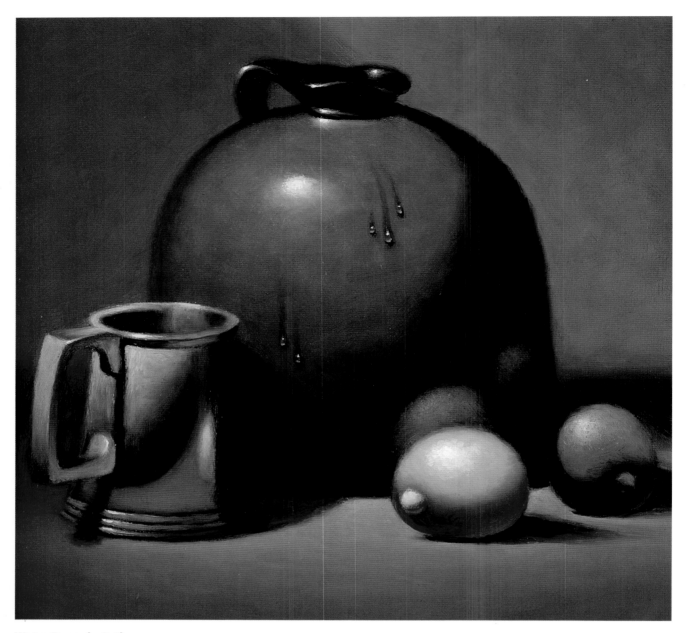

Water Drops in Action

The large jug in this piece was painted pretty much as I saw it, but by adding the water drops in a darker value than the jug, I was able to suggest the illusion of frosty coldness. Whether painting an object that is bone dry or soaking wet, blanketed with dust or highly polished, tonal values alone create the illusions being sought.

Lemon/Lime, Alex Kedzierski, 11"x 12"(28cm x 31cm), Oil on canvas
Collection of Robert and Renee Pierce (photo by Donald J. Nargi)

ANALOGOUS COLOR

Colors that are adjacent to each other on the color wheel are similar or have a common link and are called analogous colors; for example, red, red-violet, violet, blue-violet and blue are all linked by red and blue. Similarly, the strings of colors from blue to yellow (including blue-green, green and yellow-green) and again from yellow to red (which includes yellow-orange, orange and red-orange) are also analogous colors. In a broader sense, analogous colors can also be referred to as harmonious colors, for obvious reasons.

COMPLEMENTARY COLORS

Whereas analogous colors are harmonious, bear a close color family resemblance and lie side by side on the color wheel, complementary colors are about as far apart as they can get. Located directly opposite each other on the color wheel, complementary color pairs do have one thing in common: Each pair is composed of all three primary colors. This is important to know because it makes it easy to figure out complementary pairs. For example: Red is complemented by a mixture of the remaining primaries (blue and yellow, which make green). Orange, a mixture of red and yellow, is complemented by the one remaining primary color, blue. Even intermediary colors are complemented by equal amounts of the missing primaries (theoretically). Red-violet, a mixture of two parts red to one part blue, is complemented by yellow-green, a mixture of two parts yellow to one part blue. Based on that, finding the complement to yellow, for instance, should be no trouble. Right?

Here is a value map if ever I saw one: light values in the distance, middle values in the middle ground and rich dark tones in the foreground. I do not want to suggest that this is merely a pedantic study in values, however. The artist's exciting use of color, and particularly of temperature contrasts, is what really turns me on. What might have been a ho-hum, monochromatic green-on-green picture is turned into an atmospheric site wherein I can sense the listless heat of late summer and the cool shade that foretells of the brisk weather to come. I particularly like her subtle use of rusty oranges in the middle-distance trees and the way she breaks up the uniformity and adds texture to the large foreground shadow mass by scribbling into it with cool-hued Neocolor II water-soluble crayons.

View From Warrensville Road, Dorothy L. Angeli, 11¼"x 11¾"(29cm x 30cm), Watercolor Collection of the artist (photo by Donald J. Nargi)

Exact complements create the most excitement when placed side by side, and the most neutrality when mixed. But in addition to being opposite colors, complements are also opposite temperatures. Therefore, any relatively cool color, in combination with any relatively warm color, would exhibit similar, though more subdued, complementary-like effects. Any cool color will complement any warm color to some extent, and vice versa.

THREE METHODS FOR DETERMINING INTERMEDIARY COMPLEMENTS

Before studying the methods for determining intermediary complements, memorize the three complementary pairs that cover the primary and secondary colors. This will make further work with color, and specifically with complementary colors a lot easier. The complementary pairs are yellow/violet, red/green and blue/orange. Use mental images as aids if necessary: yellow daffodils with violet irises, a sliced orange with blueberries, red roses with green leaves (or the traditional Christmas colors), for example.

Method One

When naming an intermediary color, name the primary color first, followed by the secondary color. Never label a color greenish blue or purplish red, for example; use blue-green or red-violet. Think of intermediary colors, or better still, write them, in abbreviated form using uppercase letters to indicate the primary colors and lowercase letters for secondaries (here's where my shorthand comes into play); for example, blue-green and red-violet become Bg and Rv. To get the true complement of either of those intermediaries, identify the complementary color for each component — but in reverse. In the case of Bg, first find the complement of g (which is R, or Red) then of B (which is o, or orange). Now write the intermediary complements in the form of a fraction: Bg/Ro (blue-green/red-orange). Similarly for Rv, first establish the complement for v (which is Y) then for R (which is g) to arrive at Rv/Yg as your intermediary complements fraction.

Method Two

Whenever I need to mix a rich and lively dark accent color, or a colorful black, I invariably reach for one of three pairs of tube colors: Burnt Umber and Ultramarine Blue, Burnt Sienna and Phthalo Blue, or Sap Green and Alizarin Crimson. As it happens, each of those six colors is an intermediary, and combined, they produce intermediary complement pairs, or fractions. Burnt Umber (Yo) and Ultramarine Blue (Bv) combine to make Yo/Bv. Burnt Sienna (Ro) and Phthalo Blue (Bg) combine to make Ro/Bg, and Sap Green (Yg) and Alizarin Crimson (Rv) add up to the fraction Yg/Rv. In each instance, an exact complementary pair is made. If I translate Ro to Burnt Sienna in my mind (or vice versa, which I automatically do), I instantly equate it with Phthalo Blue or Bg. The same holds true for the other two pairs: By identifying half of a fraction with a specific intermediary color, I immediately envision the opposite tube color, the second part of the fraction.

Method Three

Use mental images: a peacock (Bg) eating tangerines (Ro), a sliced avocado (Yg) with some diced beets (Rv), or grape jelly (Bv) and peanut butter (Yo). (Certainly, some mental pictures that are less bizarre or more palatable work just as well.)

TRIADS

A triad is simply any three adjacent colors on the color wheel. It can be based on a primary color and its two intermediary colors, a secondary and its intermediaries, or an intermediary and its surrounding primary and secondary colors. (If that sounds confusing, refer back to the color wheel —

just as I had to do. Since the concept of color is very visual, reading about it in black and white does not have the same impact as seeing the actual colors.)

The central color of a selected trio would be the most effective neutralizer for its complement. However, the two colors to either side of the central color would also make effective modifiers. For example: yellow and its intermediaries, yellow-orange and yellow-green, make up a triad. Yellow is the most obvious choice as the true complement of violet. However, either yellow-orange or yellow-green could also be used to neutralize violet, but more subtlety. Likewise, violet along with red-violet and blue-violet would make up the complementary triad for yellow. Either of the three colors could be used to neutralize yellow (to greater or lesser degrees). An intermediary color (such as red-orange) plus its primary and secondary colors (in this case red and orange) would produce the triad that effectively modifies the intermediary's (red-orange's) complement (blue-green).

COLOR PERCEPTION

At first glance, the study of color theory would seem to be pretty straightforward. There are six colors of the spectrum and six colors in between. There is chroma, temperature, hue and value, and analogous and complementary colors. Pretty simple, right? Wrong! There also are optical illusions caused by certain visual phenomena, or laws, that alter our perception of color and value. These laws work both independently of and in conjunction with each other — which means that there may be occasions when it is unclear which particular phenomenon is at work at any given time! But, hey — ain't we got fun?

The Law of Simultaneous Contrasts

The Law of Simultaneous Contrasts simply states that tone or color will look lighter than it actually is when placed near or surrounded by a darker color. That same tone or color will also look darker than it is when adjacent to or surrounded by a lighter value. This same law is responsible for the fact that a low-, or dark-, valued object contracts, or appears smaller, in contrast to a high-, or light-, valued object of identical size and shape, which seems to expand, or grow larger than it actually is. Of course, these objects must be side by side for the contrast to be observed.

An understanding of this prin-

ciple is important, as it allows the artist to lighten a color visually without actually doing so (and running the risk of deadening the color or making it chalky) by simply darkening the surrounding area slightly. Conversely, the artist can darken an area, without fear of muddying the color or resorting to the use of black, by lightening adjacent passages. (Sometimes both lightening and darkening may be necessary to get the desired result.)

A knowledge of the contraction/expansion concept can help when painting symmetrical objects. A perfectly drawn outline of a vase, for instance, which could be measured for accuracy to the zillionth of a millimeter using the

most precise and sophisticated tools, might still look lopsided when the shadow is added to the side that is opposite the light source. There could be times when intentional distortion is needed in order to arrive at the visual truth!

Colors as well as values are altered by simultaneous contrast. Cool colors appear cooler, even downright cold, when surrounded by warm colors, while warm colors seem warmer still, even hot, when placed near cooler colors. In the same vein, colors appear brighter or duller when surrounded by or placed near duller or brighter colors than themselves.

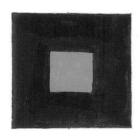

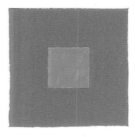

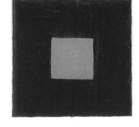

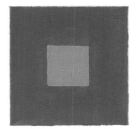

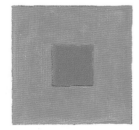

Optical Illusions at Work

These six three-inch squares were painted in the colors of the spectrum and allowed to dry thoroughly. Then, one-inch squares of identical value and neutrality (a mix of black and white) were painted into the center of each colored square. Because of certain phenomena, the gray squares are affected by four different optical illusions. The Law of Simultaneous Contrasts causes them to look lighter or darker than their surrounding values. At the same time, because light tones seem to expand and dark values appear to contract, the gray squares may also look larger or smaller than they are. With the same law still at work, they look warmer or cooler than the colors that surround them. And finally, because of the law of The Induction of Complementary Colors, each gray square is tinged with the complement of its surrounding color. These effects are very subtle and often difficult to see at first, but as a more discerning eye is developed, subtle shifts in color, value and temperature (as well as chroma) become easier to recognize.

The Induction of Complementary Colors

The law of The Induction of Complementary Colors states that colors cast their complements into nearby colors. For example, a fairly large area of red casts its complement of green into an adjacent area that is yellow, influencing the appearance of the latter so that it looks like yellow-green (Yg). This quality is most noticeable when two complementaries are placed side by side — orange and blue, for example. The orange makes the blue look bluer (more intense) by virtue of the fact that orange casts its complement (blue) into the adjacent blue color. Obviously, the blue casts its own complement (orange) into the orange color, making the orange appear even more orange (or intense). In another example, suppose yellow is placed next to neutral gray. This causes the gray to appear cooler because the yellow casts its complement of violet into the gray area. The gray definitely has a tinge of violet in its makeup. Likewise, if green is placed next to neutral gray, the gray appears warmer and has a reddish hue.

The Phenomenon of Successive Images

The Phenomenon of Successive Images can also be thought of as The Law of Afterimages. Here we become aware of the fact that when our eyes become fatigued (as when looking at a single spot of pure color for a half minute or longer), the spot begins to jiggle and dance before our eyes, and our optic nerves scream for relief. The moment we look away (at an area of blank white paper, for instance), a phosphorescent-like, glowing afterimage of that color's complement floats in front of us

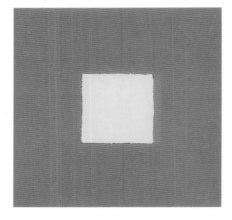 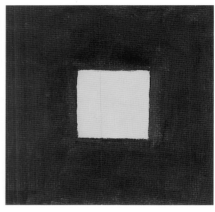

Because of The Induction of Complementary Colors, Cadmium Yellow Light, when surrounded by red, looks cool and even a little greenish. The same yellow surrounded by blue looks relatively warm and leans a bit toward orange.

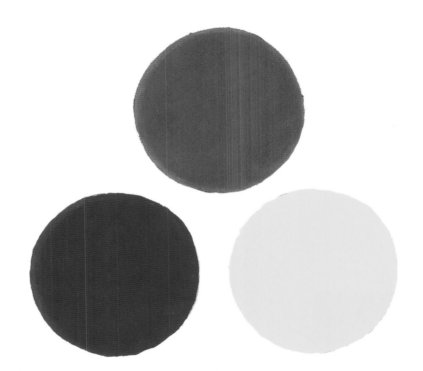

The Phenomenon of Successive Images ...

Stare into the center of one of the colored disks while slowly counting to thirty (one hippopotamus, two hippopotami, et cetera). After about ten or fifteen seconds, you will notice a luminescent aura surrounding the disk. *Do not* let your gaze shift; keep your focus on the colored disk you chose. (You are allowed to blink, however, if you must.) At the end of thirty seconds, look down into the blank white area of this page. You will see a phosphorescent afterimage of the disk you chose in its exact complement floating in front of your eyes! You may also see complementary versions of the other two disks — although slightly weaker because they were viewed only peripherally. After a few seconds, when the strain on your optic nerve has been relieved, this afterimage will fade and disappear. After a minute or so, you may wish to try this test on the other two disks — then again, you may not!

for a few seconds. When our eye-strain has been relieved, the image fades. This works with black and white as well as with color. Take a look at the illustrations of the primary colored disks and of the black-and-white squares. Take the test described in the captions to see this phenomenon in action.

What does this prove? It proves that in order for us to paint the effects of natural light, we must often simultaneously use all three primaries (thus creating a tertiary mixture). This is most often accomplished by using complements to neutralize pure color, and it is most often done in shadow passages. Adding green to a dark red shadow, for example, combines red, yellow and blue in that shadow. Sometimes a complementary color may be used in highlights as well. For example: The white highlight on a green glass bottle could have a tiny spec of red added to it. The highlight will still look white, but it will also look more brilliant (because of The Law of Simultaneous Contrasts).

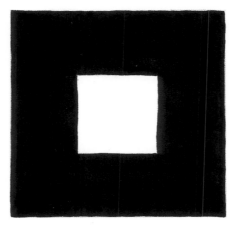
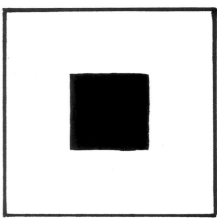

...Or The Law of Afterimages

Focus on the center of the small white square on the left or the small black square on the right. Slowly count to thirty, then glance upward to the blank white of the page to see a complementary afterimage dancing in front of you. Neat, huh? The white you now see is even whiter and brighter than the white of the page! Of course, although black and white are exact complements of each other, they are achromatic (colorless) tones, so what you see will seem to be a simple reversal (or negative image) of what you saw.

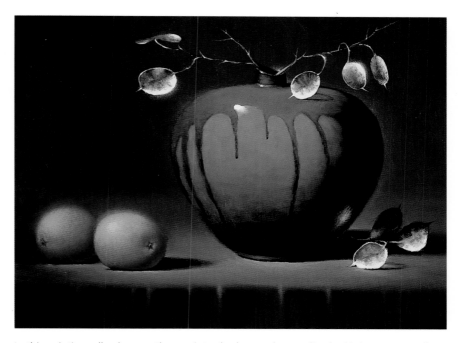

In this painting, all color was thrown into shadow and neutralized with its own complement: The yellow-green vase was subdued on its shadow side with red-violet (Alizarin Crimson) and the vase's color in light was modified with Burnt Sienna (a warm but not exact complementary color) as its form rolls under toward its base and away from the light source; the oranges were likewise shadowed with small amounts of Ultramarine Blue; and the dark, murkier violet passages were knocked back with a dark, dull yellow (Burnt Umber).

Composition in Secondary Colors, Alex Kedzierski
12"x 16"(31cm x 41cm)
Oil on acrylic-gessoed cold-pressed watercolor paper
Collection of the Pennsylvania College of Technology (photo by Donald J. Nargi)

And Now for Something Completely Different!

A fourth, so far unnamed and unheard-of phenomenon (as far as I know) exists. You can see it for yourself by just winking. Here is how it works: Close one eye. Then look at something for two or three seconds. You do not have to focus on anything in particular — an overall view is fine. But do not let your one-eyed gaze wander. Now, open your closed eye while simultaneously closing the other. Hold for a couple of seconds. Then simultaneously open and close, switching eyes. Continue this switch winking for a short time until you are alternating winks from one eye to the other a little more rapidly, holding for about one second for each open eye.

What you should notice is a shift in color temperature from one eye to the other. If you aren't familiar with the concept of color temperature, or are not yet sensitive to it, you may not be able to immediately recognize what is happening. But in time, as you are more and more exposed to the many facets of color theory through your work with color, your understanding of color will grow and you will be able to experience this phenomenon. One word of warning: You can get away with this winking caper as a passenger in a vehicle (I often do), but don't try it while driving!

I have brought this exciting phenomenon to the attention of several of my colleagues, and they all agree that after having winked for a while, they perceive warmer color through their left eyes and cooler through their right. Based on that, I think I can safely conclude that this is a normal condition and that everyone with binocular vision is blessed with this gift.

But how does this knowledge help us as artists? By proving once and for all that since warm and cool complement each other, they also neutralize each other, so we always perceive all colors with some minor degree of neutrality. This allows us to get in there and gray down any raw, garish color as it comes from the tube without any hesitation or compunction (although we certainly will not always want to or need to). Working with a predominantly neutral palette will help us to produce more natural-looking results — and ultimately, less amateurish results. Any smaller passages of pure, bright color are naturally subdued slightly through our ability to see warm and cool temperatures simultaneously.

COLOR MIXING

I cannot remember ever having a student who has not at one time or another said to me, "One of my biggest problems in painting is mixing colors." Several factors affect whether color mixtures will be successful. For most beginning students, one of the real problems is that they do not correctly identify a color's name. An even bigger problem is the fact that they do not want to waste any paint, so they lay out tiny bits of color, scattered haphazardly over the palette, and expect it to cover a large canvas. Or worse, they put out just the colors they think they are actually going to need — sometimes just one at a time as the need arises!

Once again, the big picture cannot be covered within the pages of this book, but I can at least address some of the big problems often encountered when working with colored pigment, including those mentioned above. Though this book does not contain all of the answers, there are plenty of excellent books devoted specifically to color theory and its use in painting (I own a good many of them myself).

TIP

When your goal is a light mixture, the sand or sky, for example, start with white and slowly add color to it; when aiming for a dark mix, begin with your darkest color and slowly lighten with lighter color of the same family and/or white.

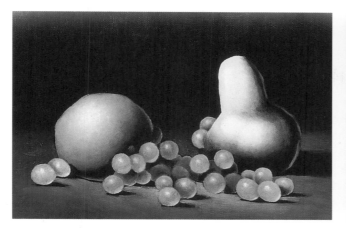

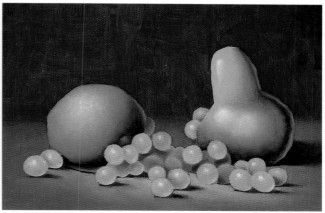

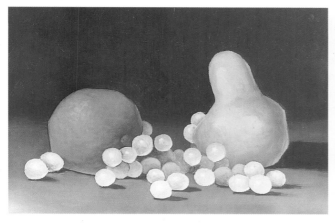

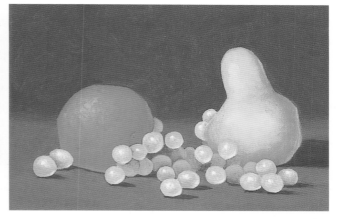

This setup of an orange, green grapes and a yellow pear on a violet ground was quickly sketched in oils — twice — just to prove the importance of tonal values over color in representational painting. In the top example, strong contrast in values produces an eye-catching, dramatic picture. Below, the absence of rich darks and sparkling lights results in an image that is dimensionally flat and tonally monotonous.

Surprise! Although the color in the top picture is a tad unorthodox, the image remains a strong one with great visual impact, due entirely to the use of strong value contrasts. Of course, this is exactly what would be seen if, for some bizarre reason, the fruit was spray painted in these toxic hues. The painting on the bottom, however, even with correct colors, remains flat and dull. By increasing the contrast of tonal values, this painting could be salvaged and turned into an exciting visual event. (The bottom picture was particularly difficult for me to do — I kept getting way too much tonal contrast for the purposes of illustrating this point!)

Naming Colors Correctly

Remember, there are only six colors of concern: yellow, orange, red, violet, blue and green. Therefore, do not identify colors by such ambiguous names as brown, beige, cocoa, coffee and chartreuse. Think of the six spectrum colors as home colors because, when it is necessary to emphasize or neutralize a color, its complementary color must be used to do so — and there is no complement for beige, or even brown for that matter.

In addition to the six colors, remember that each of these colors has four properties to be considered: hue, temperature, chroma and value. Rather than confusing the issue and hindering color-mixing efforts, these four attributes of color are of great assistance.

Four Properties, Four Questions

Here is how it works: Before trying to name the color of a specific object, try to determine the actual color of, say, brown. Believe it or not, brown is actually either yellow or orange. The two most common and useful browns are the umbers and the siennas. The umbers are both dark, dull yellows. Tinting them out with a little white paint makes it evident that Burnt Umber is warm and leans toward orange. Raw Umber, on the other hand, is cool and leans toward green. The siennas are in the orange family, with Burnt Sienna clearly exhibiting a rich reddish tendency, while Raw Sienna obviously leans heavily toward yellow.

Now suppose you are planning to paint a beach scene. Your problems may be coming up with a believable color for the sand. You cannot call it tan or beige because those two colors are not found in a rainbow (as are the six spectrum colors on the color wheel). So the first question you must ask yourself is, "What color is sand?" Well, it's obviously not blue, violet, green, red or orange, so it must be yellow.

Next ask, "What temperature is it?" It may lean a little toward orange (warm) or green (cool), or it may be fairly neutral, possessing neither warm nor cool tendencies. In my version of this sandscape, the day is clear and sunny, so my sand has a warmish quality.

The third question is, "What is its chroma, its level of brightness or dullness?" It has to be either bright, dull or somewhere in between. I see it as very dull, at least compared to a lemon, or even a block of unfinished wood.

And finally, "Is it light, dark or between those two extremes?"

Mixing the Desired Color

We know that the sand is very light (or it is if you correctly answered the last question above), so begin the mixture with a big glob of white paint. Then add a very dull yellow to the white. Cadmium Yellow Light is obviously not the answer. Try Yellow Ochre on for size — but just a bit at a time. Well, that mix is close, but not really dull enough, so add small amounts of the dullest warm yellow, Burnt Umber. Ah, that is more like it. (If you start your mixture with Burnt Umber, you will see immediately that it is too dull, so you would add bits of ochre until you get what you are after.)

Changing a Mixture

Once a good (and plentiful) base mixture is achieved, invariably it will need to be lightened, and perhaps brightened, to use in nearby passages for variety. Almost certainly, the mix will have to be darkened and neutralized to paint shadow passages. Do *not* simply lighten or darken the entire original mixture! Begin changes at the edge of the original puddle, using a small part of it in the new mixture so the first color relates to the second. Reserve a portion of the original color, just in case it is needed for minor repairs.

MY TYPICAL PALETTE

- The Yellows
 Cadmium Yellow Light
 Cadmium Yellow Deep
 (occasional use)
 Naples Yellow
 (occasional use)
 Yellow Ochre
 Burnt Umber (Yo)
 Raw Umber (Yg)
 (occasional use)
- The Oranges
 Cadmium Orange
 (occasional use)
 Raw Sienna (Yo)
 (occasional use)
 Burnt Sienna (Ro)
- The Reds
 Cadmium Red Light
 Venetian Red
 (occasional use)
- The Violets
 Alizarin Crimson (Rv)
 Manganese Violet (Bv)
 (occasional use)
- The Blues
 Phthalo Blue (Bg)
 (occasional use)
 Ultramarine Blue (Bv)
- The Greens
 Phthalo Green (Bg)
 (occasional use)
 Phthalo Yellow Green
 (Yg), (occasional use)
 Sap Green (Yg)
- The Achromatic Tones
 Ivory Black
 Titanium White
 (not shown)

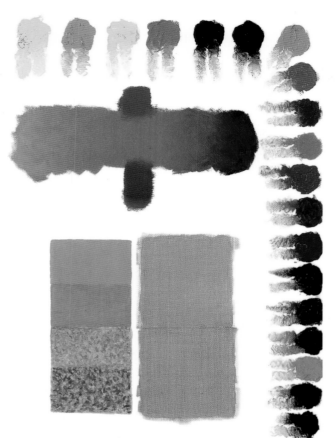

My Palette

My colors are laid out in spectral order from yellow to green with white and black added. In the horizontal rectangle in the top center, Cadmium Red Light, which is in the middle, is darkened on one edge to the right with Alizarin Crimson, neutralized and thrown into shadow on the far right with a bit of Sap Green. Moving to the left from the red home color, I add a little Cadmium Orange, then lighten the color further with some Titanium White. Compare this lightened red mixture with the blob of Cadmium Red Light tinted out with white on the far right edge of my palette. I think you will agree that the mixture is more exciting than the tint!

There are also two vertical rectangles. The top sample in the left rectangle is a physical mixture of Cadmium Yellow Light and Cadmium Red Light, both very strong, high-chroma colors. Yet the physical mixture is nowhere near as bright as Cadmium Orange straight from the tube, and shows how quickly chroma is weakened through mixing.

The next left-hand rectangle is a physical mixture of Cadmium Yellow Light with Alizarin Crimson. This orange is made duller by the presence of blue in the Alizarin Crimson. The bottom two left-hand samples use the same three tube colors as at the top, but were applied in a pointillist manner, producing more vibrant, interesting oranges than the flat mixtures above. Components of both yellow and red are visible but optically mix to form a single color when viewed from a short distance or when you squint.

At right, a single rectangle was painted with Cadmium Yellow Light and allowed to dry thoroughly. Transparent glazes (Cadmium Red Light at the top and Alizarin Crimson below) were added to produce the most luminous mixtures possible.

A Formula for Body Shadows

The body shadow color theory I use is simply this: Darken the body color (the color that is illuminated by the light source), then neutralize it with a bit of its complementary color. For example, an apple, painted mostly with Cadmium Red Light on the illuminated side, would be darkened with Alizarin Crimson, then made shadowy with a bit of Sap Green. Remember The Phenomenon of Successive Images, which proved all three primary colors must be used in order to simulate the effects of white light's energy.

How Cast Shadows Are Painted

According to my methods, the color of the surface upon which the cast shadow falls determines the complementary color used in the composition of the cast shadow's color. An apple's cast shadow on a yellow banana would be made of a darker yellow plus violet, not green. The same red apple's cast shadow falling onto an orange would be a mixture of darker orange plus a bit of blue, not green. The apple, banana and orange are all resting on a surface in front of a wall, both of which have been draped in blue. All three objects cast their shadows onto the rear wall and tabletop. These cast shadows on blue surfaces must be painted with a mixture of darkened blue plus dark orange — not with green, violet and (only) blue!

MY PALETTE

Before I go too far with talk of paint handling and color mixing, let me introduce my palette. I arrange my colors in spectrum order, beginning with yellow and ending with green. Then I add black and white. All my colors are laid out from lightest and brightest to darkest and dullest in each family. My palette usually consists of about eight to ten can't-do-without colors plus black and white, though I occasionally use others when some special need requires it. Remember that the fewer colors on the palette, the easier color mixing becomes, and the more color unity is attainable in the finished work.

Glazes and Tints

Each color shown at the top and right edges of my palette has been thinned to a glaze (to the left of each color) and tinted with white pigment (to the right). Each color is brilliant when reduced to a glaze with medium. But admixtures of white paint quickly reduce a color's intensity, simultaneously cooling and graying the color.

COLOR MIXING

These are two very different (but valid) approaches to mixing color: physical mixing and optical mixing. Be aware of both types because they each influence the look of finished work.

Physical Mixing

Physical color mixing is simply combining two or more colors on the palette before applying them to the support. Yellow combined with blue or red to make green or orange are examples of physical mixtures. They usually account for a high percentage of the mixtures used in the finished painting.

Optical Mixing

Optical color mixing refers to combinations of colors that are applied separately but, when viewed from a distance, blend together optically to form a single, luminous color. Four types of optical color mixing are: broken color, glazing, drybrushing and using patches of color. No method takes precedence over the other, as each is dependent upon the style of the particular painter.

Using Broken Color

Broken color is color that is very lightly mixed so that the resulting pigment shows streaks of all the components used in the mixture.

Glazing

Glazing is the technique of applying thinned transparent color (usually dark) over dried opaque paint (usually of a lighter value) to produce incredibly luminous optical mixtures. Light passes through the transparent layer, bounces off the underlying opaque color and reflects back to the viewer.

Drybrushing

Also called scumbling, drybrushing involves taking a color, usually of a lighter value, and dragging or lightly scrubbing it over a dry darker color in such a way that both colors and both values are visible simultaneously.

Using Patches of Color

Used extensively by the Impressionists, this technique utilizes many small strokes of patchy or spotty color, often in complementary colors, to produce an effect of vibrating light.

LIGHTENING AND DARKENING THE VALUE OF A COLOR

Whenever possible, begin lightening a color with a lighter color in the same family. This is particularly advisable with warm colors, which lose chroma quickly with additions of white paint. If the lightened color needs further lightening, slowly add white in small amounts until achieving the desired result. For instance, begin to lighten Cadmium Red Light with a bit of Cadmium Orange or a smaller speck of Cadmium Yellow Light, then add white in small increments. However, it is not always feasible or desirable to lighten in that way; sometimes it is necessary to start lightening with white.

To darken values into shadow, begin by darkening a color with a darker color in the same family, then add small amounts of complementary color or black if needed. For example, darken Cadmium Yellow Light with Yellow Ochre or Raw Sienna. To darken further, add Burnt Umber, then a violet or black if necessary or desirable. Black works OK with cool colors but turns the warm side of the color wheel murky.

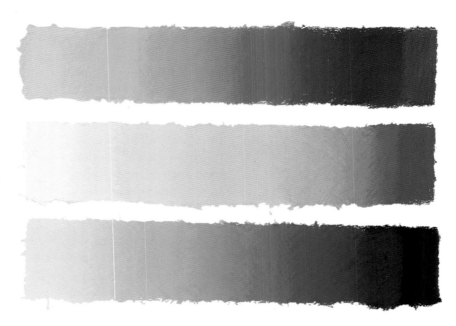

Blending and Neutralizing Color With Pastel
The three strips of primary colors were tightly crosshatched (no fingers or stumps were used to affect blends) to get gradations from lightest tints on the left to darkest shades on the right. In each instance, a complementary color was laid down at the far right prior to overpainting, then the darkest base color was feathered over it. I left a bit of the complementary color exposed to show that neutralization took place only after both complementary pairs were combined.

APPLYING COLOR TO TONE

Start with one of the grisailles
from a previous chapter and
apply color, as shown here.

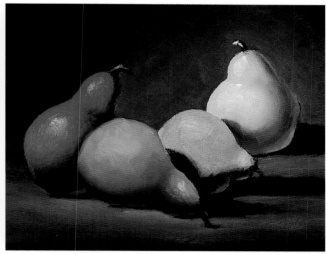

Step 1: Start With Glazes of Local Color
Begin to develop the piece with thin glazes of local color. The
paint should be thinned to a soupy consistency with plenty of
medium (I am using Winsor & Newton's Liquin here) and should
be kept transparent.

Step 2: Add Opacity
After drying, begin to overpaint with more opaque mixtures,
approximating the local colors a little more closely and sticking to
the values in the original grisaille as much as possible. However,
be open to making changes if necessary, both in value relation-
ships and in color.

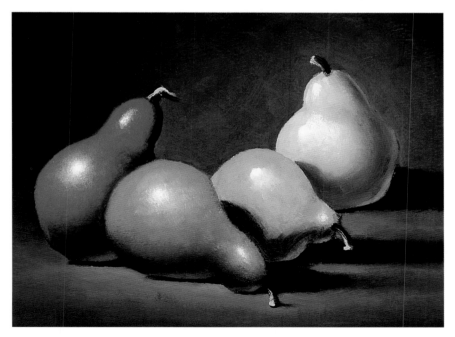

Step 3: Add Thicker Paint and Refine Color
Add another layer of thicker opaque paint, and refine colors while
also increasing contrast in values.

REMEMBER:

- Color has four properties: hue, temperature, chroma and value.
- Orange can only lean toward yellow or red, so it is always a warm color. All other hues can lean toward either warm or cool.
- Tertiaries are mixtures of all three primaries in any proportion. All colors neutralized with their complementary colors are tertiary mixtures.
- Renoir is reported to have called black "the Queen of all color!"
- Exact complements create the most excitement when placed side by side, and the most neutrality when mixed.
- Any cool color in combination with any warm color would exhibit similar effects.
- Think of the code letters to identify intermediary colors: Ro, Yo, Yg, Bg, Bv and Rv.
- Colors cast their complements into other nearby colors.
- When the goal is a light mixture, start with white and slowly add color into it.
- When aiming for a dark mix, begin with the darkest color and slowly lighten if necessary.
- A formula for shadows: darken the body color, then neutralize it with a bit of its complementary color.
- Glaze with greatly thinned transparent color only — not even the tiniest speck of white should be present.
- Drybrush or scumble with fairly dry opaque mixtures.
- Apply velaturas with greatly thinned white paint or any color to which some white has been added — in effect, this technique is a semiopaque glaze.

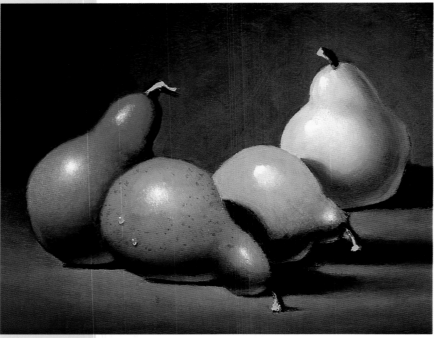

Step 4: Add Finishing Touches

Finally, finish the work by using glazes and scumbles to further strengthen the value contrasts and refine color. It is at this stage of development that details can be added, such as the brown speckles on the bosc pear.

Pear Variations, Alex Kedzierski
6 ¼" x 7 ¾" (16cm x 20cm)
Oil on acrylic-gessoed cold-pressed watercolor paper
Collection of the artist (photo by Donald J. Nargi)

A FEW COLOR MIXING TIPS

1. Avoid using more than three colors in a mixture (plus black, white or gray if needed). You will then avoid making mud and will more readily be able to match a given mixture at a later date.

2. Avoid overmixing colors — use a light touch. It is not only OK to have your mixture show a few streaks of the different components, it is downright good. Remember, you will continue mixing the paint as you brush it onto your support. This kind of broken color is much more lively and exciting than the flat, dead color you get through overworking the paint. It is also easier to do patch corrections later on parts of a picture with broken color. Trying to perfectly match a one-dimensional, overmixed, flat color is virtually impossible.

3. Lighten or darken a color with another lighter or darker color of the same family whenever possible. Then, if needed, add white, black or a complementary color.

4. When changing a mixture in any way, do not change the whole puddle that you worked so hard to get. Instead, begin your change at the edge, incorporating some of the original mixture into it so the new mix will relate to the old. Reserve part of the original color in case it is needed for minor repairs.

5. Do not try to judge color, value, temperature or chroma while the paint is still on the palette, which might be anything from brown wood to white paper, which will influence the appearance of those four qualities. Instead, paint one or two short strokes where they should go on your canvas. Then evaluate your mixture in the context of the surrounding areas in your picture. If it is not quite what you want in relation to your picture, adjust the mixture, place another couple of strokes on your canvas and reevaluate.

6. Do not paint an entire passage before evaluating a mixture. If the mix is wrong, you will have to scrape off all the paint or wait for it to dry before repainting the passage with the correct mixture.

7. Do not paint a light mixture into a dark or shadow passage. It is impossible to adequately cover a wet light mixture with a dark one. Paint your light only up to the beginning of the shadowed area, then paint the darker value onto the dry area next to the light one. Finally, carefully blend the edge where these two values meet to create your half-tone — unless the form is cubical or pyramidical (as with an obelisk), which requires a sharp edge.

8. Keep asking yourself those four all-important questions: What color is it? What value? What temperature? What chroma? The correct answers can make all the difference between success and failure.

9. To paraphrase the late, great Helen Van Wyk: You can always find the right color (value, temperature, chroma) if you mix the wrong one first. (The trick is to recognize its wrongness, then to make it right by adjusting.)

10. When painting dark colors or shadow passages, use thin paint (not necessarily transparent, but smooth or textureless). This will greatly minimize the risk of ambient light reflecting off of textured paint and creating implausible highlights where they should not be. Paint lighter values thicker, reserving your thickest impasto applications for highlights. This sculptural paint quality will (and should) effectively reflect light back to the viewer.

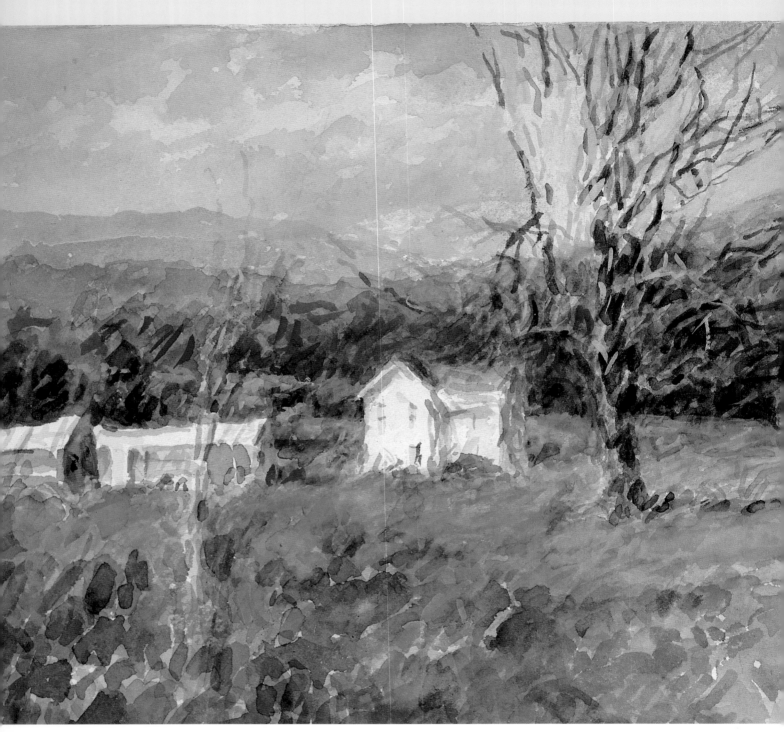

David Hopkins's subtle but valid use of tonal contrast is very different from the excesses I strive for in my intensely spotlighted still lifes. He relies just as strongly on contrasts of color intensity and temperature as he does on values to depict a very natural sense of dimension and aerial perspective. He intentionally loses or downplays some passages by using close values so as not to compete with his center of interest (the white farmhouse), but never to the point of ending with a flat, monotonous overall image. His impressionistic dot-and-dash brushwork and his gorgeous use of neutralized color make it difficult to see some of the sophisticated nuances in his work, but believe me, it is worth taking a long, careful look.

Valley Below, David M. Hopkins
7"x 11"(17cm x 28cm)
Watercolor on paper
Collection of the artist
(photo by Donald J. Nargi)

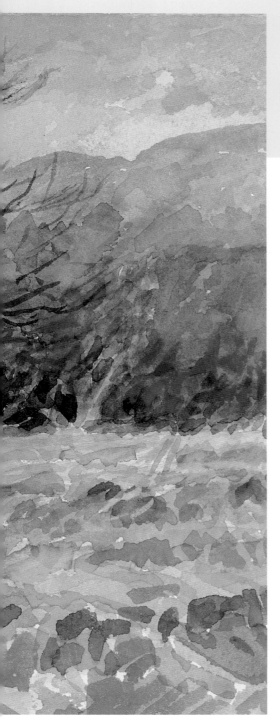

The High Value of Correct Values

In the previous chapter, I covered many aspects of color theory, including tonal values. But in this chapter, I will concentrate almost exclusively on color and its relationship to values — even if I have to occasionally use black and white!

How we perceive and render values in our work rests to a great extent on our individual personalities. For example, my own work, I am told, describes me perfectly, whereas the work of more subdued personalities would reflect those artists' characters equally accurately. And their work could be equally correct.

I am not suggesting that you need to undergo a complete metamorphosis in order to use values effectively. But you do need to learn to recognize and rectify problem areas or weaknesses in your work. You need not worry about becoming a Kedzierski clone. Once you understand these theories and techniques, they will become so much a part of you that you can let them go and allow your real self to shine through without constraints.

THE FEAR OF CONTRAST

Strong contrasts, whether visual, auditory or tactile, command our undivided attention and invite our close inspection. This knowledge makes depicting strong value contrasts very difficult for some of us.

Subconsciously, the notion that we will draw attention to our work through strong value contrast might terrify us if we feel our work is either weak or deficient in certain areas, such as in drawing, composition or color. Subconsciously, we may then opt to protect ourselves from negative criticism by using very close value relationships or low contrast so as not to draw attention to our work. We may even convince ourselves that the use of low tonal contrast promotes tonal unity — which, I feel, though valid, would produce only a one-dimensional uniformity at best. Playing it safe effectively closes off any invitation to examine our work more closely and invites the public to move on to other pictures. Granted, this will achieve our subconscious goal of avoiding the possibility that anyone will look at our work long enough to discover its real or imagined faults, but what is the point? Face it, artistic growth is not a by-product of stagnation!

Paint as Villain

Not everything can be blamed exclusively on the artists themselves. The pigments they use to produce their art can be, and very often are, directly responsible for many technical and aesthetic problems. There are some physical properties of paint that make successful manipulations of the medium next to impossible. However, it is the artist's responsibility to learn as much as possible about effective handling of the medium and, through that knowledge, overcome technical challenges.

What to Do?

If you are using low contrast to avoid discovery of your weaker points, stop now! Instead, determine what your weaknesses are and fix them. Learn to draw if that is your problem; get books on composition, perspective, color theory or whatever you need help with, and study them. After all, what is the point in producing lackluster artwork that people are not going to take the time or effort to look at? Your goal should be to grab the public's attention and hold it. Your work should invite comment — perhaps even incite argument. Of course, there will always be those who love your work and those who hate it. Ignore those who hate it — it is their loss!

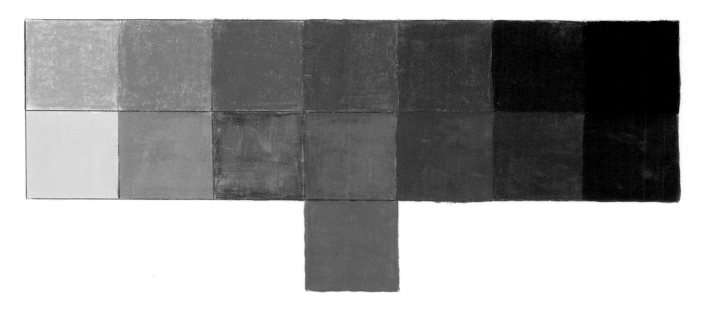

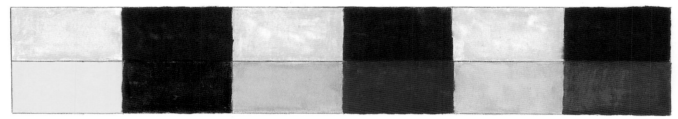

Color and the Gray Scale

There are many charts around like the top one above, which shows various-colored squares against corresponding gray-toned squares of similar value. But how do they help? Obviously, yellow is light and violet is dark, and red and green fall somewhere in between.

What is more helpful is to look for areas of light value against areas of dark value, and vice versa (not specific light or dark colors), then depict them in that way as seen in the second chart above. If there is a passage whose two adjacent values are very close, changes may be desirable. It is the artist's duty and prerogative to manipulate those values (lightening one and/or darkening the other) for the good of the painting. The success or failure of the work depends primarily on the handling of value contrasts. Of course, there will be times when close values are needed to subdue, or knock back, areas of the picture, even if the value contrast is sharper than desired; but more often than not, the opposite will be the case. This intentional juggling of contrasts to fill a need is known as artistic license. Use it!

LOOKING AT VALUES

Whenever light is present, we really only see three things: form, color and values. Period. These can be, and usually are, broken into smaller, more finite units. For example: Form, or shape, can be seen as having a light and dark side (values), as large or small; it can be named after a specific geometric shape, be smooth or coarse textured, be shiny or dull and so on. Likewise, color can be intrinsically light or dark, have both light and shadow sides (once again, values), be bright or dull, or be warm or cool. As these examples point out, values are seen at all times and must be depicted effectively on all forms (for dimension) and with all colors (for the sheer beauty of it). In their own right, values can be dazzlingly, even blindingly, light or ominously dark.

Seeing Values

I have often read that the artist, in order to see color values more readily, should imagine seeing them in black and white, or should translate color into black and white in the mind's eye. Hey, get real, OK? I cannot imagine anyone imagining color in black and white — or wanting to, for that matter. Nor can I conceive of anyone even having the capacity to translate color into tones of gray in his mind's eye. What the artist *should* be seeing is color. After all, it is there. But he should also be seeing tonal values simultaneously. They are there, too, and cannot be avoided.

Since everything in art is relative, what the artist must learn to do is see values as single masses and then compare each separate mass to adjacent and other nearby value masses. For instance, when working on a portrait, he considers whether the shadow mass on the face (while looking at the model or reference material, not the painting) is lighter or darker than the hair in light or the hair in shadow. Also, is the hair in light lighter or darker than the background value, and by how much? Is the hair in shadow lighter or darker than the background, and by how much? How about the hair in light next to the face in light? How do the various values in her blouse relate to the previously mentioned value masses? And so on. Notice that there were no questions about the color. (Also, do not forget the artist must squint while making these comparisons.)

Occasionally, two adjacent values may be very close, or even identical. How to handle that situation depends on whether the artist wants to draw attention to that area of the picture. Either he can depict exactly what he sees, or he can alter the values. In either case, the choice must be made for the good of the painting!

Values Do Not Exist in a Vacuum

No single value by itself has meaning. Consider a blank wall. Hang a picture on that wall, and there is a world of difference. (Incidentally, the appearance of a single piece of art will change dramatically depending on the tone and color of the wall it is hung on. Be it a light, middle or dark value, that wall will strongly influence the painting's overall apparent color and temperature as well as its overall apparent value.)

I used to use very dark colored mats for my predominantly dark paintings framed under glass, in order for them to look comparatively light. Now I use extremely light, neutral mats exclusively so that the paintings look even darker, and that the lights within the painting — the ones that matter — look even lighter and brighter!

Everything Is Relative

Any mixture of paint on the palette, no matter how accurate the value, is nothing more than a puddle of pigment. The artist may see a particular mixture as a shadowed flesh color, but an observer who does not know that subject matter would probably see the mix as mud. By placing it within the context of a portrait, however, and within the ambience of all the other values, it could glow with the warmth of life. Of course, if any of the values are appreciably off in one direction or the other, the overall image could be weakened and the audience might experience something of a letdown.

Seeing Values at Work

The top row of this illustration to the right includes three blue pitchers against a middle-valued background. It is immediately apparent that the pitchers will have to be noticeably lighter or darker than the ground value in order to be seen — even though the colors are contrasted.

In the middle row, body shadows have been added, which helps the center pitcher a little by virtue of its contrast with the background, but the pitcher itself is virtually invisible (just squint to see how weak the middle values are when placed side by side).

On the bottom, additional lights, reflected lights and a cast shadow were added to the pitcher and table. But more importantly, the background values were manipulated through gradation to show off all three pitchers to the best advantage, giving each small picture a strong visual impact. Of course, using a pair of complementary colors (orange and blue) did not hurt the impact either.

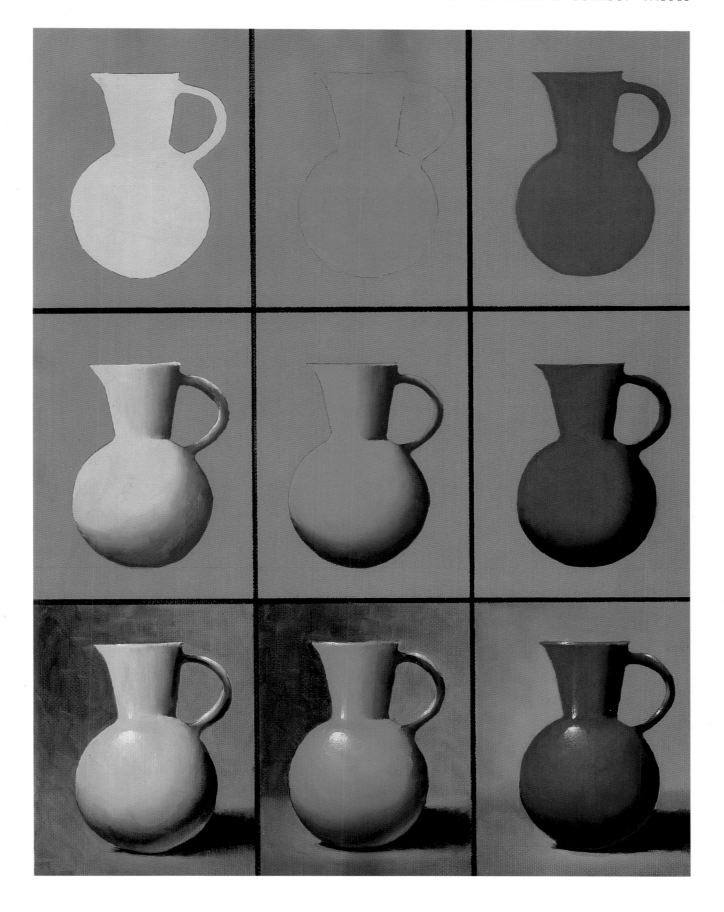

INTERCHANGE!

In chapters one and four, I introduced you to an optical illusion known as The Law of Simultaneous Contrasts. When seen in nature, and particularly when emphasized by artists through exaggeration, this illusion is referred to as interchange. Most beginning painters, striving diligently to get the right color, completely overlook the importance of the right values, thereby missing the opportunities to utilize interchange in their work.

The phenomenon of interchange is constantly at work, but it can be seen most effectively outdoors when observing a telephone pole or smoke rising from a chimney, for example. Both the pole and the smoke will appear light against the (usually) darker background of the landscape elements but will look appreciably darker and will be seemingly silhouetted against the much lighter value of the sky, even though we know both the telephone pole and the smoke to be of uniform value throughout.

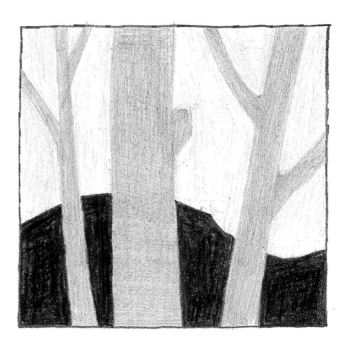

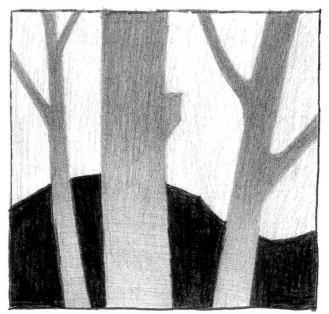

Recognizing and Exaggerating Areas of Interchange
Because of The Law of Simultaneous Contrasts, the middle-valued trees in the illustration at the top, placed against lighter and darker background elements, appear slightly darker against the sky and lighter against the distant hills. By actually darkening the upper trunks and limbs and lightening the lower portions, as I have done in the bottom illustration, this illusion will be exaggerated and the image will be stronger, more interesting and varied.

A LITTLE PRACTICE

Though easy to see in a book, the real trick to tonal values is to recognize them in one's work, where color contrast might adversely influence perception of value contrast. Most people who have tonal contrast problems almost always lean in the direction of low contrast, or very close values. Interestingly, however, they will consistently produce work in either a low key (all dark values), a high key (all very light values) or somewhere in between (all middle-of-the-road values).

To get a better handle on the effective use of values, try the following exercise as illustrated here. Paint the silhouette of a circle against a background of contrasting color as shown in step one (the two colors should be as close in value possible). Paint it once with both circle and background values light, once in a middle value and again with both as dark. Squint at each version to see the color contrasts merge and the images disappear.

Then, as shown in step two, adjust the values in each picture to solidify the circles, to make them dimensional and to show them off to their best advantage (if using oils, wait until the first step is dry). In each instance, sufficiently lighten and/or darken values to reach this goal. The only rule is to change dull, flat images into strong and dramatic visual events by using only strong, dramatic contrasts. When finished, take particular notice of how all three pictures are improved, not only in terms of value but in terms of tonal variety. After all, variety is an essential ingredient in the creation of an interesting image that will grab and hold the attention of anyone viewing the art — including potential buyers!

Step 1
Paint three circles, each against a background of contrasting color. The color of each circle and of its background should be as close in value as is achievable. Paint it once with both circle and background values dark, once in a middle value, and again with both as light.

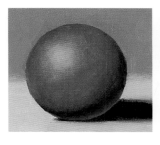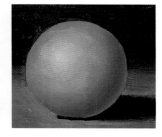

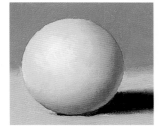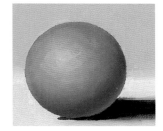

Step 2
Now adjust the values in each picture to make the circles three-dimensional and more solid. Make each picture as dramatic as possible, and create as much tonal variety as possible.

Edges and Space
Remember that close values make edges, even fairly hard edges, appear softer (out of focus) than they actually are. This in turn causes areas of low contrast to recede into space. Conversely, high-contrast value relationships emphasize passages, creating crisp edges (in focus) that are thrust forward into space. These seemingly in- and out-of-focus areas suggest a strong sense of movement from foreground to background space.

In this illustration of a fan, even though it occupies a shallow depth of field, there's an evident feeling of undulating movement back and forth and in and out between the pleats. This is due to the use of alternating high- and low-contrast values.

A GALLERY OF TONAL VALUES

The following paintings are by several artists in various media. These paintings are minutely analyzed and dissected in an effort to clear up the issues of using tonal values vs. color more effectively. As these works will show, color, which is indeed beautiful in its own right, is merely frosting on the value cake.

It is a bit difficult writing about high value contrast when that contrast is so evident, as in this painting. What else can I possibly say that cannot already be seen in the picture? Take note of how both high and low contrasts were used to deliberately emphasize or subdue passages of this painting.

Daisy Reflections, Alex Kedzierski, 11 ¹/₂" x 8¹/₂" (29cm x 22cm)
Oil on paper
Collection of Linda J. Lechowska
(photo by Donald J. Nargi)

Shadowed petals are tipped with light to separate them from adjacent dark values and to push them forward.

Lower contrast softens edges and pushes the form back into space.

A subtle reflected light separates the vase from the background and adds volume to the form.

Darker values at the bottom show the vase's form turning under and away from the light source.

Soft-edged lower values help to sink reflections below the table's shiny surface.

Movements from deep shadow into bright light add a little mystery and a lot of drama!

Dark, dull edges and corners enhance the important area of your picture.

Something that is evident in a great deal of my work, and particularly obvious in *Coral and Floats*, is my use of dark values and dull colors along the top, side edges and in the corners of my pictures. This is a compositional device I use frequently. It concentrates light and bright colors centrally with the picture plane and prevents a viewer's gaze from wandering from my picture and onto someone else's!

Coral and Floats, Alex Kedzierski
21" x 14" (53cm x 36cm)
Oil on paper
Collection of Jeff Derus
(photo by Donald J. Nargi)

Use reflected lights to separate form from cast shadows and increase the illusion of volume and dimension…

…or to show cork texture in shadows.

Use close values to downplay areas, or even to lose edges.

Shadows on white are darker than surrounding values.

Light and shadows on stems are both lighter and darker than the background.

In this vignettelike painting of calla lilies, the values in the shadows on the white flowers are very dark — even darker than lighter passages on the darker-colored background and leaves.

Calla Lilies, Alex Kedzierski
14"x 11"(36cm x 28cm)
Oil on board
Collection of Kathleen Nargi
(photo by Donald J. Nargi)

Closer values subdue areas, enhancing higher contrast passages.

Dull, cool colors recede behind brighter, warmer colors, regardless of value.

Dark values at water level suggest the wetness of partially submerged objects, such as land and rocks.

Exaggerate interchange: light against dark and dark against light.

Notice the effects of interchange on the tree.

Flat, textureless washes of near identical values remain subdued, enhancing more important passages.

There is a lot to learn from in this piece, but of particular interest are the areas of interchange used on the boat's mast and the tree. Also note that the artist uses dulled and cooled greens in the far distant hill at left, which causes it to move back into space, thereby negating the rule that lighter values recede and darker ones come forward (usually especially true in landscapes). This is true of color temperature as well: A dull orange recedes while a bright blue advances, which negates the theory that cool colors recede and warm colors advance.

Resting on the Beach, David M. Hopkins
14"x 21½"(36cm x 55cm), Watercolor on paper
Collection of the artist (photo by Donald J. Nargi)

Southern Exposure, David M. Hopkins
15"x 25"(38cm x 64cm)
Oil on canvas, Collection of the artist
(photo by Donald J. Nargi)

Interchange shows value gradation from light to dark.

Red masses balance each other in volume, chroma and definition.

Dark masses balance each other in value, volume and shape.

This is a study in balance, with dead center acting as the home base for the composition (usually a firm no-no). Essentially, the painting is divided into nearly even amounts of light (sky) and middle values (the earth), and ably broken up with lighter lights and darker darks. The line of buildings runs through the horizontal center of the canvas, but the potential for monotony is offset by the vertical thrust of the trees and chimney reaching skyward, and by the small earthbound bush and its cast shadow, all of which divert attention from the long, centrally located horizontal movement by effectively zigzagging above and below the horizon line. And though the farmhouse is placed virtually dead center, it is balanced on either side by a variety of shapes and sizes of both man-made and natural elements, and by value and color changes. Much more subtle, but equally important, are the artist's handling of color temperature and chroma changes.

Forgetting the central home base of this composition and taking a view of the piece as a whole, notice how the dark conical shape of the tree at right is balanced by the spherical bush to its left, and by the dark rectangular form that connects two of the buildings (even the shapes and sizes have variety). Also note how the soft red blur on the right is balanced by the brighter, more accurately defined red shape on the left. The artist even added a casual stroke of reddish pigment to the far left corner under the eave of the adjacent white structure. Delicious!

Dull, cool color causes this dark mass to recede.

Close values push these tree masses back into space.

Notice the numerous uses of interchange throughout the painting.

This is a beautiful composition made up of basically three values: middle (which makes up the bulk of the values in this painting), followed by lights, and further broken up with lesser amounts of vertical, near-horizontal and even diagonal slashes of very dark accents. A wonderful sense of recession into space is achieved through the use of gradating values in the stream, lightening (and weakening chromatically) gradually as it zigzags through the landscape and into the amorphous background washes. Also observe the many instances of interchange the artist used.

Mill Creek, Ed Steinhilper
10³/₈"x 13³/₈"(26cm x 34cm)
Watercolor on paper
Collection of the artist
(photo by Donald J. Nargi)

So much for water being blue!

Maximum tonal contrasts pull the viewer into and through the landscape.

I do not paint many landscapes at this stage of my career, but when I do, I thoroughly enjoy the process (and the break in routine!). For me, this is a very loose style of painting, but it appears tighter than it actually is by virtue of the strong value contrasts, which make even softly painted edges look crisp. Notice the two tree masses at far right, for example. Both are painted with nearly identical brushwork, but the darker mass seems more sharply defined against the light sky, while the lighter branches seem to merge softly with the sky's tone.

The large center tree exhibits similar optical illusions. Although there is some crisp rendering of foliage within the interior of the tree, the outer edges that make up the outline are handled with the same soft, blurred brushwork throughout. The darker foliage looks more in focus, while the lighter areas quickly lose definition against the sky.

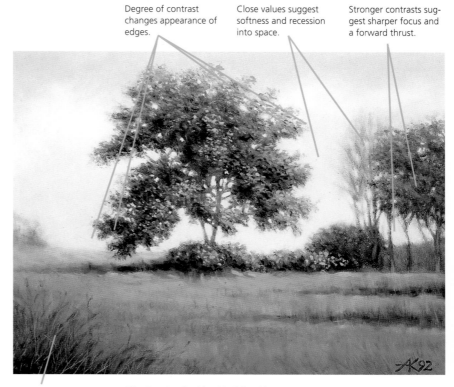

Degree of contrast changes appearance of edges.

Close values suggest softness and recession into space.

Stronger contrasts suggest sharper focus and a forward thrust.

Scratch into wet darks for contrasting light grasses.

The Patriarch, Alex Kedzierski
11"x 14"(28cm x 36cm), Oil on canvas
Collection of Joan Carole Koch (photo by Donald J. Nargi)

Light, weak colors recede.

Dark, strong colors come forward in space.

Strong value contrasts and hard edges constitute the foreground elements.

Very low tonal contrasts move back into space.

Middle-of-the-road contrasts and slightly softened edges create the middle ground.

Achromatic white moves forward and away from the dull color above it, but recedes from the brighter color below.

In this piece, rich darks dominate the image, followed closely in terms of area coverage by the middle values, and given great punch by the brilliant patches of pure white snow and brightly colored water. Notice how the intense blue-violets in the foreground come forward, while the much grayer warm colors of the background air recede.

The artist's handling of the compositional balancing act is thrilling! The large dark mass of the lower-left corner is beautifully balanced by the smaller mass in the upper-right corner. At the same time, the two middle-toned masses in the other two corners do the same. These darks and midtones form a visual tunnel leading to the heart of the picture — the colorless snow balanced by the very colorful water. The wavy dark line at the water's edge leaves no doubt about where the center of interest is.

Reflections, Ed Steinhilper
12"x 17¼"(31cm x 44cm)
Watercolor on paper
Collection of the artist
(photo by Donald J. Nargi)

Close values through-out flatten the image while enhancing atmos-pheric conditions.

Velaturas added to dry painting suggest wind-blown snowdrifts.

An overall velatura was added to knock back the tree and fence posts.

The extremely low overall contrast of this piece would seem to counter everything I have said so far about the importance of high contrast. Yet there is absolutely no other way to convincingly suggest the blustery, snowbound weather conditions except through low contrast, which effec-tively eliminates detail. It also flattens the image, thereby reducing the amount of spatial depth seen on a clearer or sunnier day. The snowdrifts were done by drag-ging a white velatura across areas of the picture after the painting was finished and completely dry. (In fact, a velatura was glazed over the entire painting in order to deaden the tree and fence, then allowed to dry thoroughly before adding the drift-ing snow.)

Blizzard of '93, Alex Kedzierski
11"x 14"(28cm x 36cm)
Oil on canvas
Collection of Joan Carole Koch
(photo by Donald J. Nargi)

USE VELATURAS

Velatura is a semiopaque glaze of greatly thinned white paint (with or without the ad-dition of another color). Just as transparent glazes give extraordinarily luminous col-or that cannot be mixed di-rectly or physically, velatura adds a semitransparent veil over already finished passag-es, which cannot be arrived at by simply lightening a mix-ture physically. You certainly could not add background air to a shadowed area with a lightened physical mixture — you would end up just light-ening the shadow, which would lose credibility and appear chalky, muddy or both.

Portrait in Sepia, John C. Bierley
18¾"x 12¾"(48cm x 32cm)
Watercolor
Collection of the artist (photo by Donald J. Nargi)

REMEMBER:

- The artist's personality plays an important role in the depiction of strong or weak value contrast.
- Our human condition, which exhibits a marked preference for light rather than shadow, can influence how we interpret tonal value.
- Strong contrasts command undivided attention and close inspection.
- Subconsciously, an artist may opt to protect himself against criticism by using very close values or low contrast.
- Your goal should be to grab the public's attention and hold it.
- There will always be those who love your work and those who hate it. Ignore those who hate it!
- If the physical properties of your medium are giving you a hard time, conquer the problem through practice.
- Do not practice on a major painting; practice on scraps with simple subject matter.
- When light is present, we see only three things: form, color and values.
- Double-checking all value assessments is a good idea.
- Values do not exist in a vacuum! (Neither do colors!)
- Shadows on a white object can be much darker than light areas on darker-colored objects.

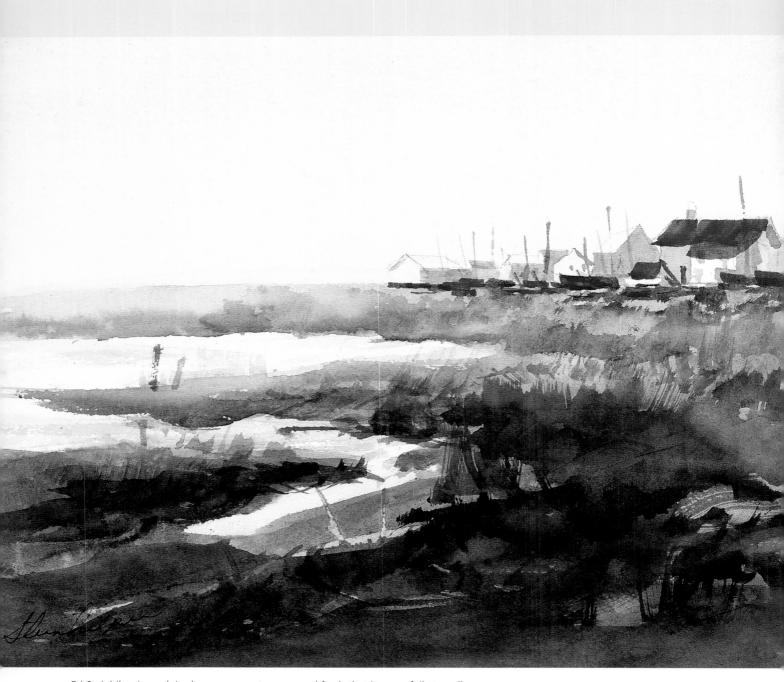

Ed Steinhilper's work is always so spontaneous and fresh that it never fails to pull me right into the picture. But, of course, the distribution of values helps a lot, too. His use of rich dark and warm foreground color leads the eye to the cool light of the S-shaped water patches, which in turn direct the viewer's attention to the cooler gray-greens at the horizon. Finally, the observer stops to admire the group of distant buildings — a nice balance of lights, darks and midtones. The simple, uncluttered treatment of the softly gradated values in the sky serves to support the excitement found below — it does not compete in any way.

Low Tide, Ed Steinhilper
10³/₈"x 13³/₈"(26cm x 34cm), Watercolor on paper
Collection of Alex Kedzierski (photo by Donald J. Nargi)

Taking Valuable Corrective Measures

Despite all that we learn and our best intentions, we all slip every now and then and end up with a flat, two-dimensional, weak picture. What do we do when this happens? One solution is to simply abandon the piece and start over again. This is sometimes the best solution (one I do not always follow, as you will see), especially if the drawing or composition is way off. But if everything else looks fine though the tonal contrast seems weak, we can increase contrast by lightening and/or darkening the appropriate passages. This is a relatively simple procedure when working with acrylics, oils, pastels or other opaque media. And though transparent watercolor can be a different matter altogether, the latitude for correction is very broad indeed and extensive corrections are not only possible but easy!

EARLY PROBLEMS WITH LIGHT AND SHADOW

Most beginning painters diligently paint only one element at a time to completion. But focusing on only one area at a time to the exclusion of all else, the artist loses the cohesive uniformity that should be present to hold the piece together. Each object becomes an individual thing, independent of the whole.

This is the direct result of two things: the artist's inexperience with handling values and working on the whole picture rather than on single parts, and the fact that her working methods produce inconsistency in both the light intensity and the shadow depth. When the amount of light falling on the objects is not of equal intensity throughout the painting, and/or when body or cast shadows vary discernibly in their tonal values (or edge handling), the overall image strikes a wrong note and the picture does not look real — no matter how well painted or detailed each individual object is.

Remember that light intensity can vary considerably, from soft natural light to the brilliance of a spotlight, and that the quality or type of light must be correctly and consistently interpreted for a picture to look believable. The type of lighting causes variations in the strength or weakness of all shadows as well (including the way the artist handles a shadow's edge). Although the artist may paint weak or strong light (or anything in between), she should not show both types of light in the same picture! Illogical lighting is what robs a picture of reality.

Consistent Light

In the illustration at the top, three completely different kinds of light are all in one picture: very soft and diffused for the pie wedge at left, strong and bright for the pie dish, and a middle-of-the-road tonality for the pumpkin. This is not a very convincing depiction of reality. But in the center picture, a strong spotlight was used to illuminate the setup. Here, light and shadow intensity is more uniform, so the piece is more logical and believable. The bottom illustration shows a softer, floodlight type of illumination. Once again, the lights and shadows are consistent with the type of lighting, which aids in giving the overall image a sense of truth.

COLOR CONTRAST VS. VALUE CONTRAST

One of the easiest ways to see contrasts of value is to fall back on the reliable technique of squinting. Squint at both your subject matter and your picture. If some of the edges in your picture seem to disappear when you squint, but hold up nicely with your subject or model, you can be sure your picture needs some tonal adjustments, no matter which contrasting colors are involved.

Look at the accompanying illustrations to see the difference between contrasting color and contrasting value.

CORRECTIVE WATERCOLOR MEASURES

I am not a watercolorist! I think from dark to light, from thin to thick, and from transparent to opaque. Watercolor frightens me. It is as simple as that. I do, however, play around with watercolors occasionally when doing color value studies for a piece I might later be developing in oils or pastels. Not being particularly competent in the medium, I botch the job more often than not.

Rather than attempt to fix things with traditional methods, such as lifting color to lighten or adding washes to darken (an approach I have tried, and one that invariably gets me into even deeper, hotter water), I use water-soluble crayons to get myself out of trouble.

I confess to not feeling too guilty about these admissions, nor too apologetic to the purists, for many traditional watercolorists (for example, Dorothy Angeli and John Bierley, whose work is seen in this book) also employ nontraditional methods when necessary — and to very good effect!

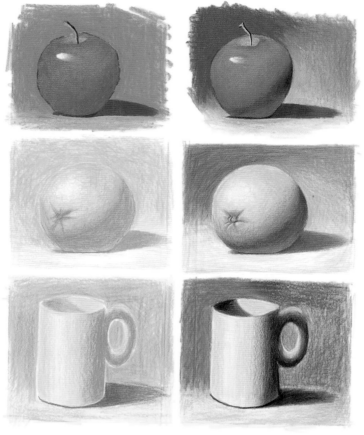

Strengthening Values in Color

In these colored pencil sketches, it is easy to see that color contrast by itself is not very exciting; in fact, when I look at the objects in the left column, I just want to ask, "So what? What's the big deal?" — particularly in reference to the object at bottom left, for which even color contrast has been diminished by using identical warm temperatures (Yo and Yg).

The right-hand column, although equally garish in color schemes, is certainly more interesting because of the greater contrast in values.

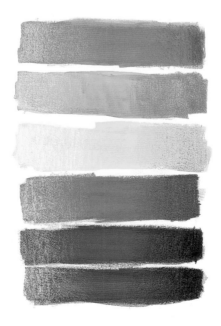

Playing With Watercolors

These watercolor washes were darkened on the right of each color with darker versions of Caran d'Ache's Neocolor II water-soluble artists' crayons, and lightened on the left of each stripe with the same manufacturer's white crayon. Admittedly, this is a far cry from the traditional approach to lightening or darkening values in watercolor, and I am probably being soundly cursed by some purists out there, but hey, I am not even an impure watercolorist, so I must do what I can to make things work. One thing these crayons can do when used dry, and with varying degrees of pressure, is provide gradations of texture, something not possible with traditional washes or even dry-brush techniques.

Better Luck With Watercolor

For the purpose of illustrating more corrective measures, I asked artist Ed Steinhilper to do a painting with deliberately weak tonal values and to then revitalize it by making the appropriate value adjustments. Take a close look at Steinhilper's before and after pieces, and see what a profound difference strong tonal values make.

Low Value Contrast Equals Low Energy
The close values in this painting lack the power needed to attract our attention and hold it. This simply composed scene is attractive and inviting, but it just does not have the pizzazz required to generate any lasting interest. Instead, it looks anemic and bland and even has a feeling of the unfinished about it.

Untitled Revision, Ed Steinhilper
10½"x 14¼"(27cm x 36cm), Watercolor on paper
Collection of Alex Kedzierski (photo by Donald J. Nargi)

High Value Contrast Equals High Impact and Drama
Wow! What a difference a little extra paint makes. The artist began his revision by wetting some parts of the near snowbank with clear water, then blotting and even scrubbing with a clean paper towel to lift some of the color and lighten the area. He then worked fresh pigment into the middle and darker values, strengthening them drastically. A rich dark wash was added to the bottom of the picture to suggest a shadow mass on the foreground snow. With his fingernail, he scratched a few limbs into the intense dark wet paint behind the trees. He added strong sienna-hued grasses for touches of brilliant warm color. When the painting was dry, Steinhilper used a razor blade to scratch back to the white of the paper to add sparkle to a few tree branches and some of the dried grasses.

REVITALIZING OIL PAINTINGS

Even with my oil paintings, every now and then I quite simply miss the mark! This unfortunate circumstance will probably occur for you once in a while too. Do not let it get you down. Just go on to a new piece, and get on with your artistic life. Occasionally, however, I hazard an attempt at pulling together a weak painting after I have had time to live with and study it a while.

Revising *The Vase*

I originally painted *The Vase* eight years ago, and its weaknesses (which greatly outweigh the meager strengths) were the result of my lack of knowledge and understanding of my medium and subject matter. I can only hope that I have grown enough to successfully reverse the balance of strengths vs. weaknesses. You be the judge. Study my step-by-step demonstration of revisions on *The Vase*.

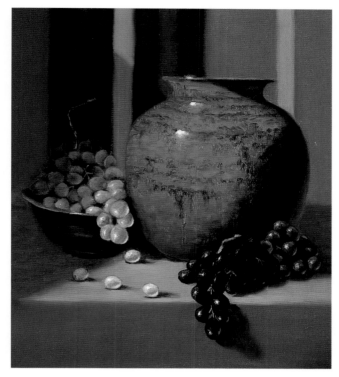

In April 1990, when I finished this piece, I really thought it was a knockout. Boy, how things change! Originally painted as a gift for my sister Isabel, she died before I could give it to her. Now, in May 1998, I hope to give it a little more sparkle and vitality.

Step 1: Correct the Shapes

I began by lightening the green stripes in the background slightly. Next, I started reshaping the left side of the vase to match the right side a little more closely. Colors and values were closely matched to the original because I needed wet pigment to paint into with the new, lighter values. The bottom of the vase was moved down a little to bring the vase forward, and the reflected light in the vase's neck was also lightened. In addition, the outlines of the grape masses were reshaped for more variety and interest. Also, an indication of a new bottom for the bowl, which makes it look shallower and farther back in space, was added (now it definitely appears to be behind the vase).

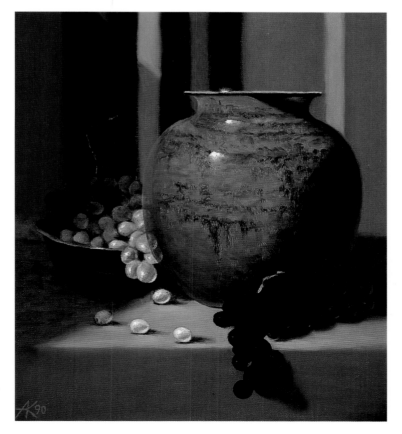

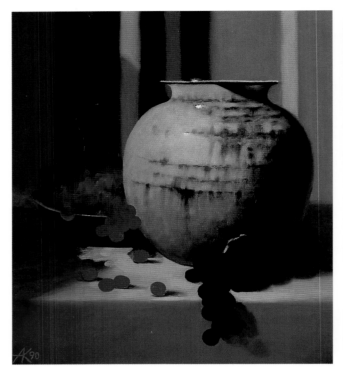

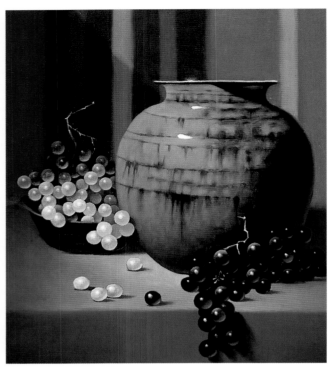

Step 2: Refine Further

I dulled the green stripes slightly with a glaze of Raw Sienna, then I began work on the vase, lightening it radically (and losing a lot of the pattern in the process!). I also played around a bit more with the reflected light in the shadow of the vase's neck. The grapes on the right were made uniformly dark with Alizarin Crimson and black, while the green grapes were repainted completely, redesigning the silhouette of the forward grapes overhanging the bowl's rim. An additional grape was added to the table to break up the monotonous line that was there originally. Finally, I began a search for table colors in full light, in half light where the cloth overhangs the table's edge, and in shadow.

Step 3: Finish the Revisions

I covered the background wall in its entirety with a velatura of a little white and even less Ultramarine Blue greatly thinned with medium (Winsor & Newton's Liquin). This step simultaneously cooled and dulled the color, suggested air behind the foreground elements and effectively forced the wall to recede in space. I used the actual vase as a reference so I could suggest the real pattern of dripped glazes rather than trying to invent it (probably with zero success). I then restated the vase's highlights and subdued the reflected light in the neck.

The green grapes were carved out of the bunch's mass shape with various mixtures and values composed of Sap Green, Yellow Ochre, Naples Yellow, Cadmium Lemon Yellow and white when needed. The haze was done with black, white and Phthalo Blue. For a more natural look, a few grapes were influenced with Raw and Burnt Sienna. The black grapes were likewise carved from the mass with some dull red-orange transmitted lights and grayed Ultramarine Blue haze. (I slightly changed the shapes of both masses where needed. I do not think I have to point out the fact that one green grape was changed to black!) I then reworked stems and highlights to complete the illusion. Finally, I redid the table's surface and overhang with, I hope, more interest and impact.

The Vase, Alex Kedzierski
18"x 16"(46cm x 41cm), Oil on canvas
Collection of the artist (photo by Donald J. Nargi)

A Less Complex Revision

This painting revision was much less demanding. It required only some value adjustments and a few refinements, including the addition of air behind the cinnabar vase, the addition of a reflected light, diffusion of grape highlights and removal of stems. I attribute the need for revisions to the fact that I went a little overboard on the grapes — and if I can go too far, even taking into consideration the fact that the extreme contrasts in my work are standard for me, then you can certainly go far enough in your own contrasts!

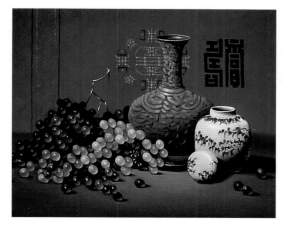

The Original Work

There are areas of this painting that have been bothering me for quite a while. By the time I finished laboring over this picture (it took 27½ hours over a nine-day period stretching from April 26 to May 20, 1996), I did not even want to look at it, much less spend as much as another single second improving it. I convinced myself that it was a decent piece of work that could stand on its own as is. Today, however, I decided that it probably would survive a few revisions. So, here goes!

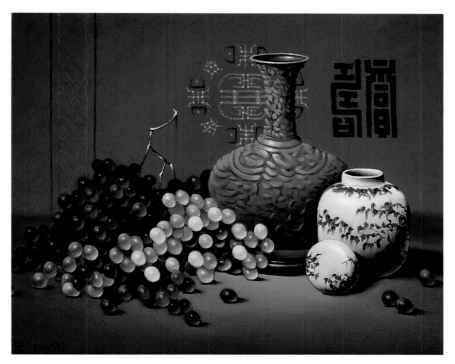

Cinnabar Vase, Alex Kedzierski
18"x 24"(46cm x 61cm), Oil on board
Collection of the artist
(photo by Donald J. Nargi)

Fixing the Problems

The most evident problem for me was the grapes. The neonlike red grapes were simply too much, and, due to the specular highlights, both bunches looked more like marbles than grapes. I toned down the reds with glazes of Ivory Black and Alizarin Crimson, then knocked back the gray bloom and diffused the highlights with dark mixtures of black, white and Ultramarine Blue. The green grapes at left were subdued with a Sap Green glaze, while select others were lightened and brightened, as they moved toward the center of the picture, with various mixtures of Cadmium Lemon, white, black and Phthalo Blue. The highlights here were diffused as well. Also note that I removed the stems from within the green bunch because they looked more like a constellation and were therefore confusing. Some shadowed grapes were painted in instead.

Next, I darkened the edges and corners of my support with glazes of the appropriate colors and small amounts of their complements. A soft velatura of white was glazed in behind the red vase to add air, pushing the wall back and pulling the vase forward. A reflected light was added to the shadow side of the ginger jar's lid to separate it from its cast shadow; the left side of the brass lip on top of the vase was also lightened to separate it from the background value; and finally, a bit more light was added to the center area of the table. All in all, I feel these adjustments have improved the painting, and so have been worth the effort.

SCULPTING BUNCHES OF GRAPES

In the previous two revisions, I worked with a lot of grapes, but gave no clues as to how I developed the grapes from a solid mass, which merely suggested their silhouette, to the final luminous and illusory juiciness of the end result. The following step-by-step demonstration of painting red and green grapes will, I hope, correct that omission and provide all the clues needed to paint a whole vineyard of grapes.

Step 1: Block in the Composition
Begin by drawing some squared-off, interesting overall shapes. Even if the silhouette of the grape bunch being observed is not particularly exciting, paint the shape so that it is. Next, scrub in some color to kill the white of the support (I am using Burnt Umber thinned with turps). Try to get a sense of the values to be used, but do not go overboard; remember, value adjustments will be made throughout the whole development of the painting. Continue to adjust mass outlines and their placement until they are satisfactory. (I am not happy with the far left line of my dark grapes, but I am leaving them as they are to show how I fix the problem. The stems, which will almost certainly be repositioned on the canvas, are there simply to provide a sharp edge for my photographer to focus on!) Be prepared to make any necessary changes to improve the grapes at any time.

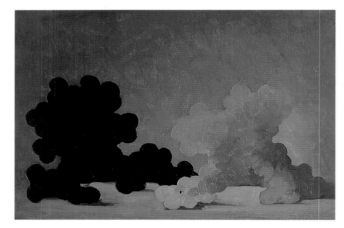

Step 2: Lay in the First Color Statement
Begin using a painting medium (I am using Winsor & Newton's Liquin) to put down the initial layer of color. (I used Rembrandt's Blue Green plus Ivory Black and Titanium White for the background color; black and Alizarin Crimson for the dark grapes; and Sap Green, Yellow Ochre and a bit of white on the green grapes, with a little more green and some Burnt Sienna added for the darker passages.) Notice how the very angularly drawn grape masses build the silhouettes of rounded grapes. These new outlines may still be changed if necessary in future painting sessions. Allow to completely dry.

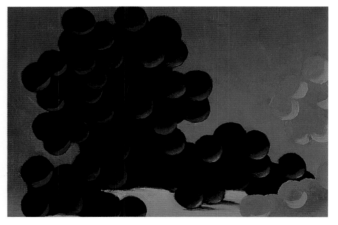

Step 3: Repaint and Carve the Dark Grapes (Detail)
Repaint the background wall with the same colors for better coverage and smoother blends, but add a bit of Burnt Sienna into the darkest shadowed passages. Paint the tabletop with blue-green and white, omitting the black. Repaint the dark grapes with crimson and black, then begin carving individual grapes into the wet mass by adding a bit of Cadmium Red Light to the original dark mixture and painting crescents of transmitted light opposite the light source. Paint only a few circles that touch just at the edges with the thought that when they are finished, additional grapes will be painted to overlap some of the first grapes. When the whole bunch is completed, there should be some gaps to suggest missing grapes and recession into space.

Wipe off the brush and carefully blend the inner edges of the crescents up into the wet dark color (see grapes at center left). Add more red to the mixture and restate the crescent of light at the edge of the original crescent. Blend the inner edge once again, being careful not to pull this new value too far up into the previous blend and thus weaken the gradation of value and chroma from light and bright to dark and dull (see grapes at center right).

Finally, add more red plus a little ochre to the last mixture. Paint smaller crescents on some (not all) grapes. Blend lightly. If additional brilliance is wanted in a few spots, add a bit of Cadmium Yellow Light to the mixture and paint tiny strokes just opposite the light source. These last additions do not have to be blended (see grapes at far right).

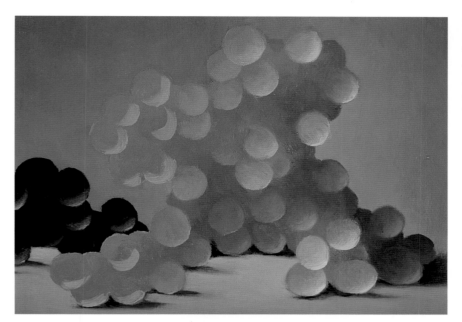

Step 4: Repaint and Carve the Light Grapes (Detail)

Working in the same manner as in step three, begin carving grapes with small additions of Yellow Ochre followed by additions of Naples Yellow. End with additions of Cadmium Lemon and white if needed.

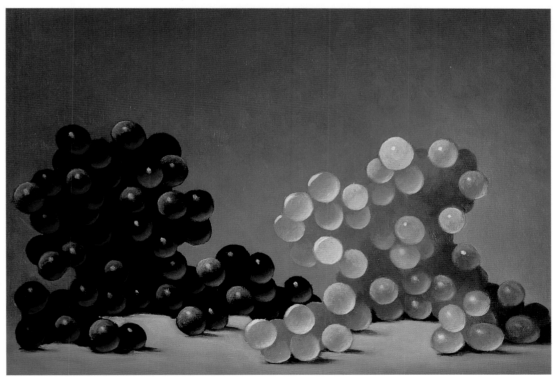

Step 5: Add the Bloom

With a dark gray made of black, white and a little Ultramarine Blue, lay in crescents of the bloom, or haze, that is often seen on grapes. These crescents go on select (but not all) black grapes, just opposite the transmitted lights. Blend gently as done for the transmitted lights. For variety, lighten this mixture with a speck of white and rework a few grapes, blending lightly. Lighten the mixture further, and put dots of pigment on some of the grapes about a quarter to a third in from the edges (never place them dead center!), then wipe off the brush and blend softly with a stippling or soft dabbing technique. Lighten the mixture once more and repeat, emphasizing select grapes with diffused highlights. The green grapes are completed in the same way, but start with a slightly lighter gray and add Phthalo Blue instead of Ultramarine.

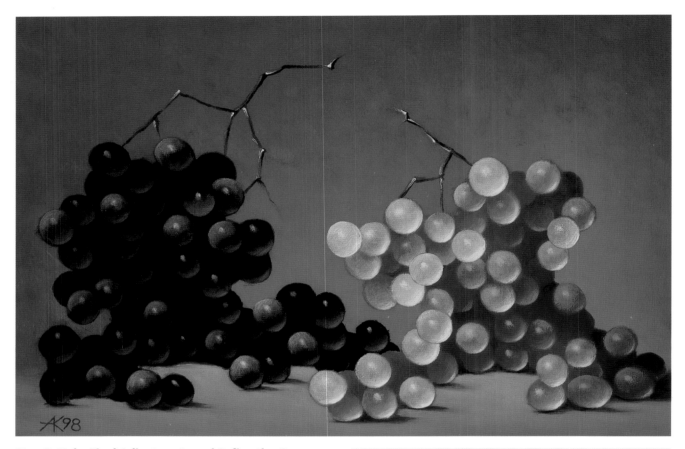

Step 6: Make Final Adjustments and Refine the Grapes
Develop the bloom and highlights fully on both bunches using a variety of values, then add the stems. Finally, after letting the piece dry and studying it for a while, go back into the grapes, darken some darks (on the green grapes) and add more light to both bunches where needed. I even added three new green grapes (more could be added if desired) and moved two of them from the interior to the front of the green bunch.

Clusters, Alex Kedzierski
9"x 13³/₁₆"(23cm x 34cm), Oil on canvas
Collection of the artist (photo by Donald J. Nargi)

AN INTERESTING OBSERVATION

When the blue-gray bloom was added to the dry grapes to the right in the painting, preventing the haze from mixing with green grape color, the green cast its complement of red into the gray, changing it to violet-gray. This is the result of The Induction of Complementary Colors. When added to wet grape color and allowed to intermix slightly, the bloom remains cooler and more natural looking. The violetish hue is interesting, although I am not exactly crazy about it. However, I am not going to lose sleep over it, either. If you run into the same problem of having to work into a dry area, simply adjust your blue-gray mixture slightly by adding a bit of the light green grape color into it. But it is easier to simply work into wet color in the first place.

THE ONE THAT GOT AWAY!

I do not always follow my own advice, unfortunately. Earlier in this chapter, I stated that there are times when the only hope of success is to give up on a piece altogether and to restart from scratch. I did not do that with *One Out of Three*, and I have had plenty of opportunity to regret it. To me, the painting does not even stand up to revisions, but I include it here to prove a point.

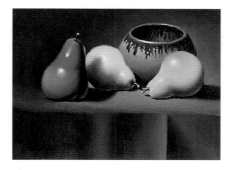

Step 1: Use Velatura for Dust and Cobwebs

I have never been happy with this picture. Part of the problem is that I painted it as a demonstration piece, concerning myself with the steps as they would appear at each stage in a photograph, rather than

for the fun and pleasure of just painting. The pears were always a particular problem. So, shall I burn the thing? Nah! I have decided to finally have some fun with it instead. Since the pears look fake anyway (especially the one on the far right, which looks more like a lightbulb), I feel that covering them with dust and cobwebs would improve their appearance. Natural fruit, on the other hand, would never survive cobwebs entering the picture (no pun intended). So to thicken the atmosphere, begin with a velatura of Titanium White and Burnt Umber, greatly thinned with medium. The ultimate goal is to have all the air, in front of as well as behind the subject matter, filled with thick, dusty motes.

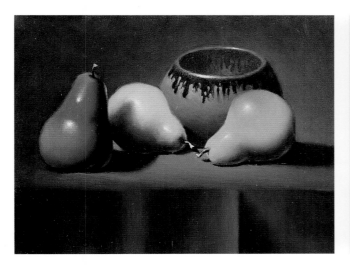

Step 2: Add Even More Dusty Air

After drying, and if needed (as it is in my version), add another overall velatura, then add a bit more pigment to the mixture for the background air and for the interior of the bowl. This will push the wall back even farther and add air inside the bowl. (If, after drying, the results of step one are satisfactory, then skip the second overall layer and just add more air to the wall behind the subject matter and to the bowl's concave interior. However, using two or even three thin layers is safer and more effective than using one heavy-handed, obvious layer!)

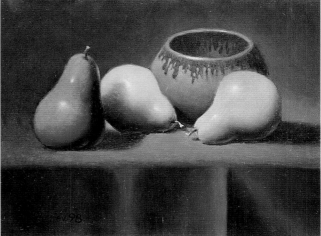

Step 3: Layer the Dust

When step two has dried, add a bit more of both pigments to the velatura and begin painting dust on all horizontal and diagonal planes (the tabletop, the tops and upper sides of the bowl and pears). Do not add dust to the undersides of the subject matter. Be sure the mixture is not so dense that detail in the underlying objects is not visible. Also, wipe the brush periodically, and carefully blot/blend the interior paint edges to prevent the impression that some dust has been wiped away. Add more medium if necessary to effect those blends. The transition should move from very dusty to not as much dust to no dust at all. Let dry and repeat for very dusty areas if needed.

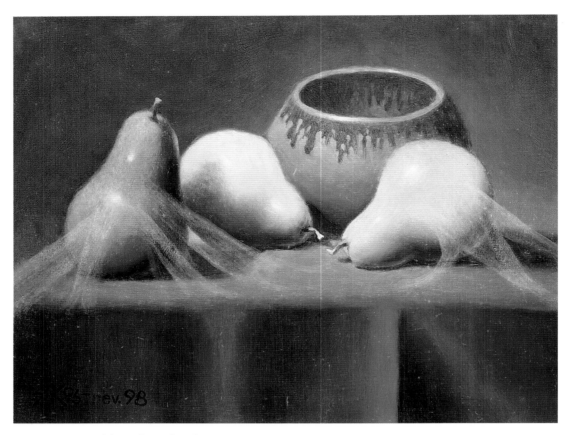

Step 4: Start Building the Cobwebs

Using the same pigments in a fairly dilute mixture, drag the paint over areas as a block-in where cobwebs are wanted, then add a bit more pigment to the mixture and emphasize some portions of the webs. Let the painting dry completely once again.

REMEMBER:

- In concentrating focus on one area at a time to the exclusion of all else, artists lose cohesiveness and uniformity.
- Because of this, each object looks as if it belongs in another picture.
- Light intensity can vary considerably, from soft natural light to the brilliance of a spotlight.
- The type of light must be consistently interpreted for a picture to be believable.
- Do not show both weak and strong types of lighting effects in the same picture.
- The easiest and surest way to see contrasts of value is to squint.
- If some of the edges in your picture seem to disappear when you squint, you can be sure your picture needs some tonal adjustments.
- We really have very few things to concern ourselves with during the picture making process: value, color, edges and impasto.

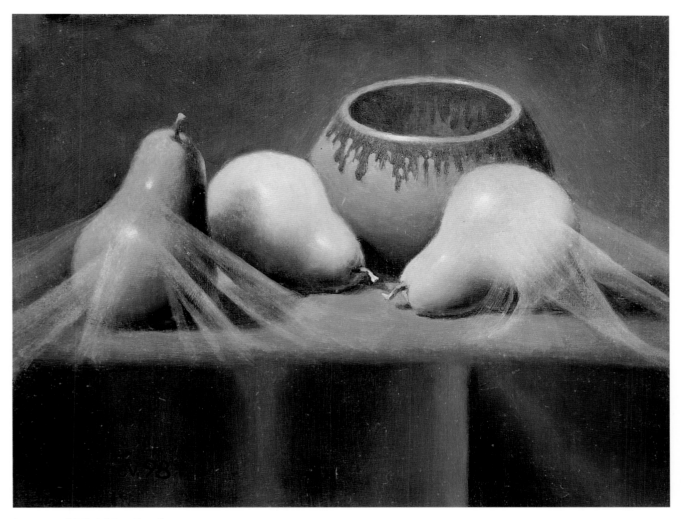

Step 5: Add Finishing Touches

Using a velatura with just a bit more pigment than usual, add varying amounts of dust to some portions of the cobwebs. If necessary, let dry and add a final overall layer of air with a greatly thinned velatura, or make whatever other adjustments seem to be needed (for example, more background air or more dust). Compare this painting with the finished piece shown in chapter three, and notice the following: Tonal value contrasts have been greatly reduced, flattening and dulling the image but greatly enhancing the murky atmosphere I sought; color intensity was greatly reduced as well, but not one square inch of the original work has been completely covered with opaque paint — all of the original color, albeit weakened as it was by the many veils of semiopaque pigment, can still be clearly seen.

John Bierley has completed three paintings in a series of this bird carcass, and I wish I had the room to include them all, as they are each completely different and are all equally exciting — and intriguingly named (*Indigo Skies* and *The Descent of Icarus* are the other two). Although petrified, the bird seems to be in agile, frightened flight, its battered wings fighting desperately but vainly against the reality of its condition.

Nevermore, John C. Bierley, 26"x 38"(66cm x 97cm), Watercolor on paper
Collection of the artist (photo by Donald J. Nargi)

Composing a Painting With Values

Using values effectively as a compositional tool depends on only two elements: the design, arrangement or distribution of values, and the balance of the lights, darks and middle values. Design and balance have already been discussed in chapter five (see *Coral and Floats*, *Mill Creek* and *Reflections*).

Of course, other things come into play as well when composing with values, including variety and the intentional placement of specific contrasting values. I will examine these additional elements and dissect some finished paintings to learn how some artists use design, balance and variety to enhance the overall composition. This chapter also presents three step-by-step demonstration paintings and how the artists (myself included) grapple with the many aspects of value, color, composition, design and balance.

FIRST THINGS FIRST

One of the first things that art students are told they must learn is the ability to *see*! By this I mean that a student must be able to observe the subject matter in the most simple terms — that is, be able to see and show a form's structure before depicting the form's detail.

The student must take the most complex visual information and depict it in the least complex way: Simple light and dark masses (squinting helps to see these simple patterns of light and dark) are used in place of the myriad value changes that actually take place. Later the painter can introduce the nuances that an infinite number of value shifts produce. Unfortunately, it is initially difficult to see the volume and structure of a head, for example, when confronted with all those details, such as eyes (and eyelashes, which are often the first thing a student wants to paint), mouths and noses. (It seems that beginners never want to bother with foreheads, cheeks and chins!)

To show some nicely balanced value masses, I produced some simple value maps of a few of Ed Steinhilper's watercolor paintings. These are, and should be, abstract arrangements of light, middle and dark tones as they will be used in the design of the finished picture.

In this untitled piece, the three values seem to have an equal amount of weight distributed throughout the picture. A closer inspection reveals that the darks are most prominent, closely followed by the lights, then by the middle values.

In the finished painting, within each of the three major value masses, Steinhilper has provided variety and interest by using slightly lighter and darker accents of each value. Also, the darks and lights are not single masses but are broken up or separated by other value masses, whereas the middle-valued mass appears only in one area of the picture.

Untitled, Ed Steinhilper, 9³/₄"x 13³/₄"(25cm x 35cm), Watercolor on paper
Collection of the artist (photo by Donald J. Nargi)

In *Pine Run*, the lights carry the greatest amount of weight. Lesser amounts of mid-tones support the glare, and a few dark accents add punch to the piece.

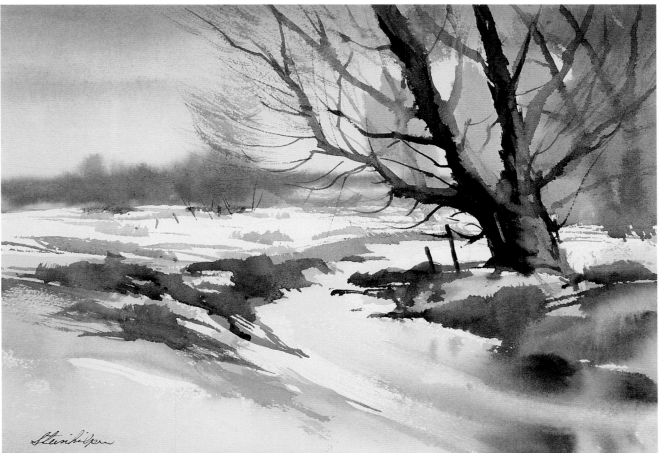

Once again, the value masses are not clumped in three separate areas but are interspersed throughout the painting, dissecting each other at various angles and degrees of proportion. As in the previous painting, and as with almost any drawn or painted image, there are variations of slightly lighter and darker values within each major value mass. Notice how the sweep and direction of the streams in these two pictures allow for a separation of

dark values and provide at least one diagonal bank (diagonals are strong attention getters in composition). This is not a formula that Steinhilper uses indiscriminately — it is just a coincidence that I chose these two pictures to be shown together.

Pine Run, Ed Steinhilper, 10¼" x 14¼"(26cm x 36cm), Watercolor Collection of Alex Kedzierski (photo by Donald J. Nargi)

Here the darks and midtones are approximately evenly distributed — the meager amount of light plays third fiddle in this piece.

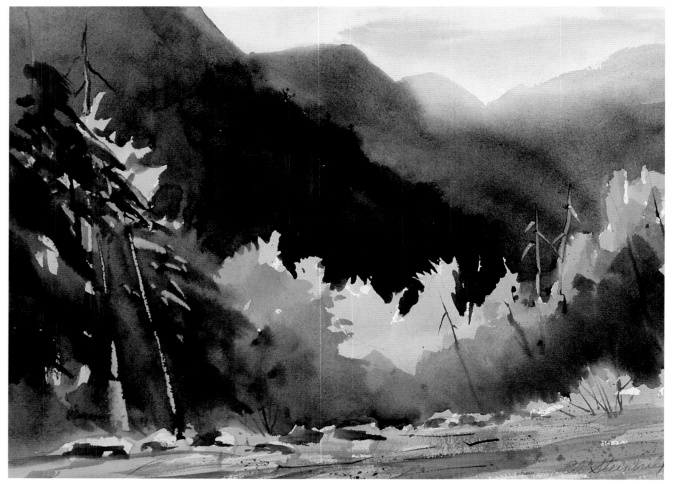

Steinhilper tells me he is trying to loosen up his painting style — he actually told me that he believes he is a tight painter! (I wonder if he has looked at any of my recent work.) The shock of those light trees against the dark hills make this piece sing and makes the observer sit up and take notice.

State Run Gorge, Ed Steinhilper
12¼" x 18" (31cm x 46cm), Watercolor on paper
Collection of the artist (photo by Donald J. Nargi)

In this last value study, it is clear that the middle values prevail over the composition, with the lights and darks coming in second and third, respectively.

The extremely simple subject matter and composition, in addition to the near monochromatic coloration, rely heavily upon nicely balanced, strong contrasts of tonal values.

Untitled, Ed Steinhilper
10³/₄"x 14³/₄"(27cm x 38cm), Watercolor on paper
Collection of the artist (photo by Donald J. Nargi)

PAINTING WITH VALUES: THE PASTEL PROCESS

I was primarily an oil painter for some ten years or so before starting to play with pastels. Today, now that I have found an affordable source for framing my pastels, I paint with them at least as much as I do with oils — if not more. Pastels are convenient and immediate. This medium does not require setting up palettes, using several brushes (which must be thoroughly cleaned after each painting session) or waiting for up to several days for paint to dry before going on. And there is never any worry about mixing matching colors (or values) when continuing to work on a piece because all of the colors and values are premixed in individual sticks.

I did not have the luxury of studying pastel painting with a knowledgeable pastelist; I am completely self-taught in this medium. However, I am a firm believer that even the most unorthodox methods that produce the desired results are A-OK.

Step 1: Block in the Composition
Begin with a quick gestural sketch in charcoal to place the composition, then cover the entire support with broad, loose strokes of color using the sides of Nupastels. Rub these colors into the surface with your fingers to get a soft overall layer of color. The objective here is to get a base of pigment down on which to build the painting with additional layers.

Step 2: Brush off and Scribble
Before beginning to work again, use a large, stiff bristle brush to whisk away excess pastel dust from the support. Be bold and brush hard! A blurred ghost of an image will be retained, but it will be enough to start building on. Then broadly scribble pigment over the entire surface to suggest values and approximate colors.

Step 3: Lighten and Tighten Up
With light pressure and tightly hatched strokes, begin to develop the sky with softer pastels — I am using Rembrandt's. Keep aware of values and placement of lights and darks. Composing with values as well as with subject matter is an effective means of directing a viewer's path through the painting.

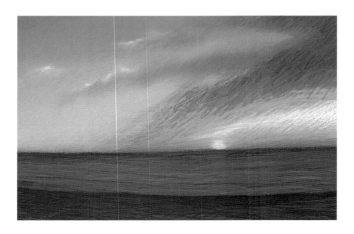

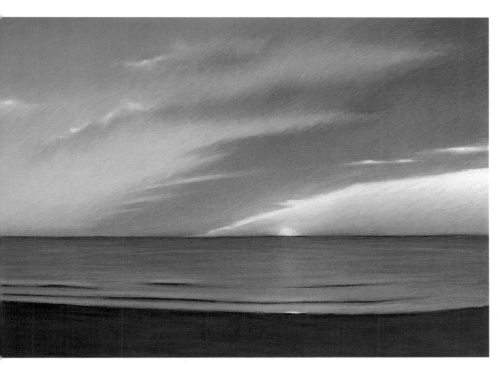

Step 4: Develop Further
Continuing in the same way, cover the entire support with pigment, then study the piece for a day or so to see where to improve values, color, chroma or temperature.

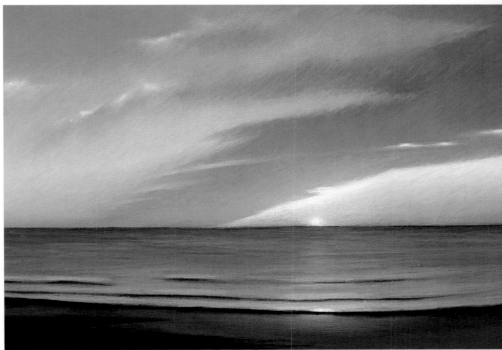

Step 5: Finish the Painting
Starting fresh after a day's rest, I used Sennelier's extrasoft pastels to make the following adjustments: The upper clouds were darkened and cooled slightly with the addition of some grayed blues; the sky around the sun was lightened considerably; the sun plus the streak of sunlit cloud above it were highlighted with very light yellow and white; the water was revised and the beach was made to look like more than just a flat patch of color, without allowing the beach to compete with the sunset.

Quiet Beach — Early Evening, Alex Kedzierski
11"x 17"(28cm x 43cm), Pastel on Wallis museum-grade sanded paper
Collection of the artist (photo by Donald J. Nargi)

PAINTING WITH VALUES: WATERCOLOR MAGIC

I am always amazed when I watch competent watercolorists at work. Many of them, but certainly not all, seem to just slap the paint on in any old way without any apparent concern for where it is going or what it is doing. They supplement the seeming chaos with splatters of contrasting colors, sprinklings of salt, wrappings of plastic film, scratchings, blottings and spongings, mistings and spritzings, and even occasional splashes of alcohol. Whew! No wonder the medium scares me. Magically, however, these artists somehow pull it all together and end up with finished and often fabulous pictures. Steinhilper is one of these magicians. He is not faster than a speeding bullet, but he is no slowpoke either!

Step 1: Plan

Steinhilper begins every new painting with a few thumbnail studies to nail down values and composition. These are very general in feeling, with the values being only suggested rather than labored over. He conserves his energy for the more demanding work on the painting itself! (When I asked him if he had any value studies for the piece he would be doing as a demonstration for the book, he dug into the large canvas bag he lugs his equipment around in and produced this stained and tattered scrap of sketch paper. I chuckled, but also appreciated the fact that, as simple as it was, the sketch still provided him with the pertinent information needed to start the painting. But I actually had to steam iron it before submitting it for this reproduction! And it didn't help!)

Step 2: Draw

Using very light pressure (to prevent impressing deep valleys into the paper's surface), lightly sketch the composition onto the paper. Do get too detailed at this point because it will all be covered by paint anyway. Besides, too much drawing or too many details may be difficult to fully cover with paint!

Step 3: Apply Light Washes

Wet the sky and mountain passages with clear water, carefully avoiding the tree trunks and foreground. Add a light wash of Raw Sienna for warmth in the sky, followed by some light streaks of Cerulean Blue. Add Ultramarine Blue to the mixture, and work it into the mountain. A bit more Raw Sienna should be added behind the tree trunks while the paper is still fairly wet.

Step 4: Begin Building With Middle Values

At this stage, the previously worked areas are still slightly damp. Take advantage of this by working some darks in behind the trees at left, then darkening the mountain area and adding a suggestion of some distant foliage into the still damp area. Finally, with a warm middle value (Burnt Sienna), begin work on the stream's bank, and with a cool violetish mixture, add a wash to the lower left corner to suggest shadowed snow.

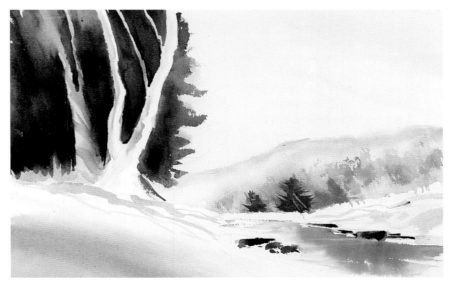

Step 5: Start Adding Darker Darks

Continue developing, adding some rich darks behind the tree trunks and painting around some of the light background values to divide the trunk at far left. Also add a couple of limbs to the one at right. Darken the trees in front of the mountain, and add some lighter valued trees in the same area. Then darken the rocky banks of the stream, and add a wash of grayed blues to the water area. Paint a few strokes of color on the tree trunks and on the ground in front of them to finish this stage of development.

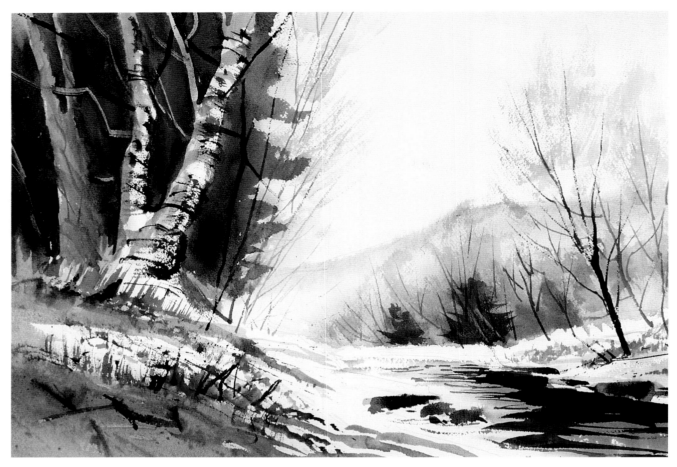

Step 6: Finish the Painting

Finally, add as much detail as desired. (Steinhilper refers to these last additions as "adding the junk.") Use a rigger brush and loose calligraphic strokes to suggest some wispy young trees in the background. Use the same to scribble in some very dark values in the lower left of the painting. Darken the area behind the trees at left even more, then scratch out some limbs with your thumbnail (or the back of your brush handle). Darken the far left tree with a wash (it is too prominent and too much like the other trunks). With an almost dry round brush and values ranging from middle to very dark, add strokes of various widths across the trunks with the side of the brush hairs. With the same brush, and very little light-valued pigment, scrub in some foliage against the sky with the side of the brush hairs (behind the skeletal trees that were done earlier with the rigger). Use a wide flat brush to add dark streaks to the water, then spread the hairs with your thumb and forefinger just below the ferrule and "flip" the tips of the hairs against the paper and upward to create the sienna-hued dry grasses. Finally, fully load a large round and splatter various values and temperatures in select areas to suggest debris — small stones and fallen leaves, for instance.

Untitled Demonstration, Ed Steinhilper
13"x 18"(33cm x 46cm)
Watercolor on paper
Collection of the artist
(photo by Donald J. Nargi)

PAINTING WITH VALUES: WORKING FROM DARK TO LIGHT

Although much of John Bierley's work is traditional and transparent, he also thoroughly enjoys experimenting with his watercolors and in mixed media. In *Wet Snow*, he begins with a darkish value, then slowly builds lights into the painting (by spraying diluted semitransparent white ink) and adds darker darks for his contrast.

Bierley's approach to his work, whether experimental or traditional, is much slower, much more controlled than Steinhilper's. Both methods are valid, however, and both rely heavily on a sure sense and use of tonal values, as does any of the work illustrated in this book.

Step 1: Wrap the Wash
Begin with an overall wash of a darkish value blue, adding a bit of violet in a couple places for warmth, then spread a sheet of plastic wrap irregularly over the wet paint and allow to air dry thoroughly (Bierley says that an hour in the sun will get the sheet bone dry and ready for continued painting).

Step 2: Assess the Texture
When dry, carefully peel away the plastic film and discard. The support should look like this, showing the texture of marblelike veins caused by the thin sheet of wrinkled plastic.

Step 3: Get Even Richer Color and Texture
Let the previous step dry completely, then add even darker darks, allowing them to roam freely at the bottom and adding some splotches of Payne's Gray in the upper right to introduce some neutrality into the image. Cover the support with a flat sheet of cheesecloth for added texture and allow to dry thoroughly, then remove and discard the cheesecloth.

Step 4: Add Trees
Using diluted Higgens Transparent White Ink, lightly draw the outlines of the tree shapes and let dry. Then, using masking fluid, brush the ink on select areas of the tree trunks (to suggest missing bark and/or adhesions of snow) and paint in all of the branches. When completely dry, lightly mist the entire support with the diluted white ink.

Step 5: Add Texture and Rewrap
After drying, reapply the masking fluid, completely covering the missing bark on the tree trunks and branches, and add fluid to the tops of some branches to represent the snow that has accumulated on those horizontal planes. Let dry, then spray once again with the white ink, alternately misting and lightly splattering the whole painting. Add a few judicious sprinklings of table salt, and cover select portions of the picture with wrinkled plastic wrap. When dry, carefully remove the film and discard it, then brush away all traces of the salt.

Step 6: Texture the Trees
Rub briskly to remove all of the remaining masking fluid to expose the darks and middle values (missing bark, snow on branches).

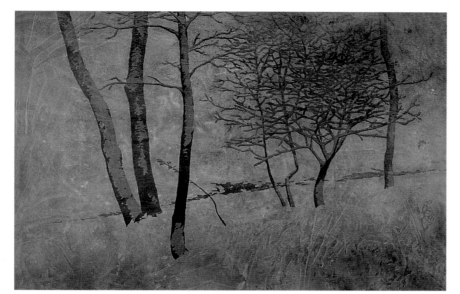

Step 7: Strengthen the Darks
Brush a reddish mixture (Burnt Sienna or Alizarin Crimson) into the dark passages of the foreground tree to pull it forward into space. If needed, brush in darker darks and accents with a grayed blue (the lower half of the central tree at left and some of the lacy branches at right were given these additions of darks and accents).

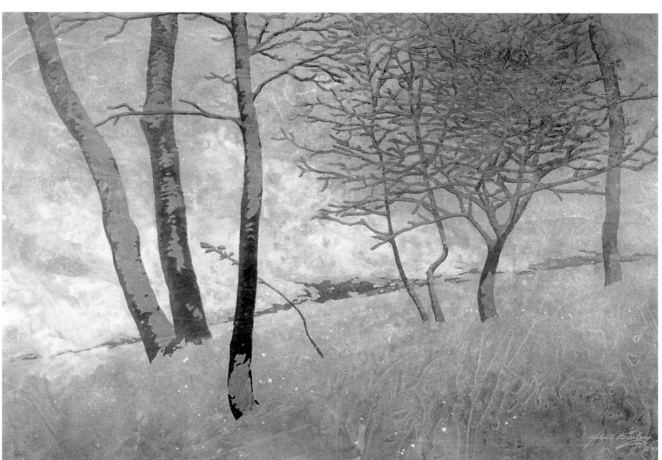

Step 8: Add Finishing Touches
Using a round brush, add some texture and movement to the distant background atmosphere behind the trees with some loose, random brushstrokes of white ink. Finally, splatter a few drops of straight white onto the lower third (or foreground) of the painting to suggest flurries.

Wet Snow, John C. Bierley
23"x 32"(58cm x 81cm)
Watercolor and transparent
white ink on paper
Collection of the artist
(photo by Donald J. Nargi)

121

GALLOPING TOWARD THE FINISH LINE!

Since a picture is worth a thousand words and seeing is believing, here are several finished paintings in a variety of mediums. Of course, the emphasis here is on tonal values, but color usage and composition are considered as well.

Ghosts, John C. Bierley
29"x 48"(74cm x 122cm)
Watercolor on paper
Collection of the artist
(photo by Donald J. Nargi)

About-Face

Although I have been harping about the importance of strong value contrasts, I must also show that when atmospheric conditions require it, less contrast is more appropriate. In Bierley's painting *Ghosts*, the overcast day demands the suppression of both values and color to the point of near invisibility. The air is made thick and silent by the softly falling snow. Although no strong diagonal lines are actually shown, the cars radiate outward from the center toward left and right, which implies a diagonal movement. The narrow space between the two central vehicles invites a leisurely examination of the background landscape elements as well as the rusting wrecks which give the painting its name. Considering the muffled silence of the scene, there is a strong sense of movement throughout the piece. (It is interesting to note that Bierley says he worked with an extremely high contrast photograph as reference material but liked the way the painting began to develop and chose to stress the soft, quiet mood with a reduction in contrasts.)

Full Sunlight

In this painting, clear skies and bright sunshine bathe the scene with light and a riot of pure color. Nevertheless, as I peer into the distance, values grow progressively lighter and color intensity diminishes noticeably. Although there are no instances of true interchange in this painting, an impression of interchange exists because the many flower heads that reach skyward are all positioned against contrasting values. There are also beautiful contrasts of temperature at work here: not only in the obvious orange against green, but in the warm yellow-greens against the cooler blue-greens. Notice, too, that each horizontal band of color and value varies in width, both one from another and within each individual band. This attention to variety, or willingness to sweat the small stuff, is what separates the artist from the hobbyist.

Near Domaine Chandon, John C. Bierley
36"x 44"(91cm x 112cm), Watercolor on paper
Collection of the artist (photo by Donald J. Nargi)

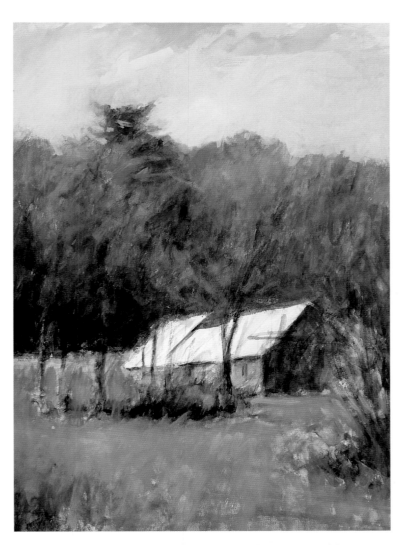

Simply Effective!

David Hopkins's work always makes me think that painting is so easy. He certainly makes it look easy! Of course, I know better. In *Overgrown With Pines*, he underpainted in transparent watercolor, often using colors that were complementary to those he expected to finish with. These opposing colors sparkle through the finished painting in spots.

After the underpainting dried, Hopkins completed the piece by scrubbing opaque gouache over much of the picture using bristle brushes. In the original, the dichotomy that is evident between the transparent and opaque passages is downright riveting. This is a favorite of mine because it is so darned simple, yet so very effective. I only wish I could afford to own it!

Overgrown With Pines, David M. Hopkins
30"x 22"(76cm x 56cm)
Watercolor and gouache on paper
Collection of the artist (photo by Donald J. Nargi)

A Dedicated Pastel

The Native American basket and clay pot were gifts to my collection of still life props from Maile Marshall, so when I finally used them in a painting, I dedicated it to her, hence the title *From/To*. Observe this piece carefully and slowly, looking for all of the many, many instances of light against dark/dark against light. There is a lot of that happening in the black vessel alone. Also notice that there is a big difference in intensity between reflected light (the interior shadow in the basket and along the upper right exterior edge) and reflections (the basket and pepper reflecting into the clay pot and the light green pepper reflecting into the underside of the basket).

From/To, Alex Kedzierski
13¹/₂"x 18¹/₂"(34cm x 47cm)
Pastel on extrafine-grit Ersta-Starcke
sanded paper
Collection of the artist
(photo by Donald J. Nargi)

Conclusion

Writing this book was a real experience — a real learning experience, actually. I can only hope that you get as much out of reading and working with this book as I did from researching many of the theories, illustrating some of the precepts and writing about it all.

It was particularly exciting for me to work on the captions for the finished art and step-by-step demonstration pieces by the guest artists. They use values beautifully, and I am happy to have learned much from studying their paintings in order to write about them.

However, although my job as author has come to an end, your job as a student of tonal values is only just beginning. Whereas I had nothing but a blank computer screen when I began, you have this finished, comprehensively illustrated book to refer to at any time. Take advantage of that fact and please use this book — but not as just an occasional source of reference. Instead, draw and paint with strong values. For example: Take advantage of your new awareness of some of the optical illusions caused by varying degrees of tonal value contrast; put them to work in one of your paintings. In short, use the information you have just finished reading about. If you seem to be losing it at any time, refer back to the book to find a solution to your immediate problem.

Draw and paint a lot! And do so while consciously using stronger and stronger value contrasts. Then just sit back and revel in the excitement of producing strong, dramatic artwork.

Chi, L. Maile Marshall, 28"x 22"(71cm x 56cm)
Watercolor and acrylic on paper
Collection of the artist (photo by Donald J. Nargi)

INDEX

A

Achromatic tones, 35, 57, 63
Analogous color, 67
Angeli, Dorothy L., 34, 60, 67
Atmosphere, creating, 60, 105

B

Background values, 15, 17
Bierley, John C., 93, 108, 119, 121, 122
Black, 63, 64-65
Blizzard of '93, 92
Body shadow, 75
Bounty, 47
Broken color, 76

C

Calla Lilies, 89
Cantaloupe, 52-54
Cantaloupe With Red Grapes, 54, 55
Cast shadows, 75
Celadon Vase With Peaches, 10
Chi, 124
Chroma, 60, 61
Cinnabar Vase, 101
Citrus Fruit, 57
Close relationships, values, 13
Clusters, 104
Cobwebs, 106
Color, 59-79
 achromatic tones, 63
 analogous, 67
 black, 63, 64-65
 broken, 76
 changing mixture, 74-75
 characteristics, 60-61, 78
 chroma, 60-61, 74
 complementary, 62, 67, 70, 71, 78
 contrast, 18-19, 91, 92, 97
 darkening, 76
 hue, 60, 74, 78
 intermediaries, 62, 63, 68, 78
 intermediary complements, 68
 law of afterimages, 70, 71
 law of simultaneous contrasts, 69, 71, 86
 law of the induction of complementary colors, 69, 70, 104
 lightening, 76
 mixing, 72-78, 79
 optical mixing, 76
 patches, 76
 perception, 68-72
 phenomenon of successive images, 70-71, 75
 physical mixing, 76
 primaries, 62, 63
 secondaries, 62, 63
 temperature, 60, 72, 74, 79, 89
 tertiaries, 62, 63, 78
 triads, 60, 68
 value, 60, 61, 74
 wheel, 62-63
 white, 63, 64-65
Complementary colors, 62, 67, 70, 71, 78
Composition, 10, 47, 90, 91, 102, 111, 114, 122
Composition in Secondary Colors, 71
Concave form, 30-32
Contrast
 color, 18-19, 97
 fear of, 82
 values, 13, 18-19, 20, 42-43, 88, 97, 98
Convex/Concave, 32
Convex form, 30-32
Copper/Onions, 21
Coral and Floats, 88

D

Daisy Reflections, 88
Darkening color, 76
Dark values, 20, 25
Diffused light, 29
Dimension, increasing, 14
Drybrushing, 76, 78

E

Edges, 17, 20, 25, 28, 29, 30, 40, 87, 88, 106

F

Farm Shed, 60
Five values, 14, 16, 17, 20, 29
Flash of Cobalt, A, 22
Form, 26, 27
 concave, 30-32
 convex, 30-32
Foundation, building, 52, 54
From/To, 123
Full range of values, 16-17

G

Ghosts, 122
Glazes, 75
Glazing, 49, 76, 78
Grapes, 42, 52-54, 55, 73, 100, 101, 102-104
Grapes and Lemons, 42
Gray scale, 12, 83
Grisaille, painting a, 35, 40-41

H

Highlights, 14, 24, 28, 31
Hopkins, David M., 80, 89, 90, 123

Hue, 60, 78

I

Ikebana Basket With Bittersweet, 43
Intense light, 29
Interchange, 86, 89, 90
Intermediary colors, 62, 63, 68
Intermediary complements, color, 68

J

Just Some Fruit, 46

K

Kedzierski, Alex, 2, 8-9, 10, 21, 22, 32, 42, 43, 46, 47, 51, 54, 57, 58, 66, 71, 78, 88, 89, 91, 92, 100, 101, 104, 115, 123

L

Landscapes, 67, 80-81, 89, 90, 91, 92, 94, 98, 110, 111, 112, 113, 114-115, 116-118, 119-121, 122, 123
Law of afterimages, 70, 71
Law of simultaneous contrasts, 12, 69, 71, 86
Law of the induction of complementary colors, 69, 70, 104
Lemon/Lime, 66
Lemons, 17, 42, 57, 61, 66
Light
 consistent, 42, 96
 diffused, 29
 edges, 25, 28, 30
 form, effect on, 26
 illogical, 96
 intense, 29
 intensity, 24, 25, 26, 32, 96, 106
 movement, 43
 planes, 25, 28
 reflected, 14, 29, 31, 32, 88, 101
 sources, 24, 30, 31
 texture, effect on, 27-28
 values, 25
Lightening color, 76
Lilies, 89
Log Cabin, 58
Low Tide, 94

M

Markers, 37, 38, 39
Marshall, L. Maile, 33, 124
Mill Creek, 90
Mixing color, 72-79
 changing mixture, 74-75
 optical mixing, 76
 physical mixing, 76
Monochromatic, 35, 57

N

Near Domaine Chandon, 122
Nevermore, 108

O

Oils, 49-51, 52-54, 64-65, 77-78, 99-
 100, 102-104, 105-107
Oil paintings, revitalizing, 99-101
One Out of Three, 51, 53, 55, 105
Optical illusions, 12, 69
Optical mixing, 76
Overblending, 16, 20
Overgrown With Pines, 123
Overpainting, 41

P

Palette, 74, 75
Pastels, 44-46, 76, 114-115
Patriarch, The, 91
Peaches, 10
Pear Variations, 78
Pears, 16, 49-51, 77-78, 105-107
Pencils, 37, 38
Perception, color, 68-72
Phenomenon of successive images,
 70-71, 75
Physical mixing, 76
Pine Run, 111
Planes, light, 25
Po Mo, 33
Portrait in Sepia, 93
Practice, 55, 56, 57, 87, 93
Primary colors, 62, 63
Problem solving, 39

Q

Quilt Beach—Early Evening, 115

R

Reflected light, 14, 29, 32
Reflections, 91
Resting on the Beach, 89
Rubbing, 44

S

Secondary colors, 62, 63
Shadows, 25, 26, 32, 78, 88, 89, 93, 96
 body, 14, 24, 28, 29, 31, 75
 cast, 24, 28, 29, 31, 75
 problem areas, losing in, 42, 43
Simplicity of values, 16-17

Sketches, 36, 38-39, 55, 56, 116
Southern Exposure, 90
Squinting, 18, 20, 39, 49, 57, 106, 110
State Run Gorge, 112
Steinhilper, Ed, 90, 91, 94, 98, 110,
 111, 112, 113, 116, 118
Still Life With Quilt, 34
Still lifes, 8-9, 10, 21, 22, 34, 42, 43,
 44-46, 47, 49-51, 52-54, 55, 57, 58,
 60, 66, 71, 77-78, 80-81, 88, 89,
 99-100, 101, 102-104, 105-107,
 123
Studio Stuff, 43
Subject values, 15

T

Tangerines, 8-9
Temperature, 60, 72, 74, 79, 89
Tertiary colors, 62, 63
Texture, 27-28, 32, 119-120
Tints, 75
Tonal range, 13
Triads, color, 68

U

Underpainting, 35, 40, 49, 57
Untitled, 110, 113
Untitled Demonstration, 118
Untitled Revision, 98

V

Valley Below, 80-81
Value maps, 35-37, 67
 creating, 38
 sketches, 38-39
Values
 background, 15
 close relationships, 13
 color, 59-79
 concave forms, 30-32
 contrast, 13, 18-19, 20, 42-43, 97, 98
 convex forms, 30-32
 dark, 20, 25
 emphasizing form and dimension, 13,
 14, 26
 five, 14, 16, 17, 20, 29
 form, effect on, 26
 full range, 16-17
 light, 20, 25
 relativity, 44
 seeing, 84
 simplicity, 16-17
 spatial relationships, 30

 subject, 15
 texture, effect on, 27-28
 visual impact, 13, 98
Vase, The, 99-100
Vases, 10, 14, 99-101
View From Warrensville Road, 67
Visual impact, values, 13, 98
Velatura, 54, 78, 92, 105

W

Watercolors, 97-98, 116-118, 119-121
Water drops, 64-66
Wet Snow, 119, 121
Wheel, color, 62-63
White, 63, 64-65